Robert Short

PAUL KLEE

With 40 color plates

GALLERY BOOKS
An Imprint of W. H. Smith Publishers Inc.
112 Madison Avenue
New York City 10016

Published by Gallery Books
An imprint of W.H. Smith Publishers Inc.
112 Madison Avenue
New York, New York 10016

Reprinted 1983

ISBN 0-8317-5375-7

Printed in Spain by Graficromo S.A.

Introduction

THE PRINCIPAL CURRENTS OF twentieth-century modernism in art meet in the work of Paul Klee: indigenous German Expressionism, abstraction inherited from Cubism and Kandinsky, Bauhaus Constructivism and Surrealism's recourse to unconscious inspiration and daring poetic analogy. Although several movements would have liked to claim him, Klee was a very private man and never committed himself to any school. His work is extremely varied, even disparate, in style, theme and mood, ranging from cubist landscapes, expressionist figures and allegorical stage-sets to geometrical constructions in which the lines of force are indicated by arrows, and coloured 'chess-boards' — pictures composed of pointilliste dots, tachiste blots, alphabetical symbols and hieroglyphs. No domain of experienced reality was alien to his imagination and he experimented tirelessly with new media, techniques and backing materials to find the precise expression for each.

In terms of quantity also, his output was awesome: he left some 3,500 drawings and from 1914 onwards sometimes completed over 200 paintings annually. It is difficult to get to grips with so diverse an *oeuvre*. As Will Grohmann, Klee's friend and biographer, confessed: 'We can never claim to embrace it in its totality and multiplicity.' Chronology is of some help because Klee's mature work was not unchanging and did respond to developments in the arts around him. But his habit of returning over the years to earlier themes and stylistic peculiarities, and of working on several pictures of very different types at the same time, means that the chronological approach by itself is misleading. There are certain constants in his work — the almost ubiquitous humour, the unique synthesis of line and colour, the harmonizing of abstraction with a poetry of the marvellous — in which we recognize the authentic Klee spirit.

Perhaps the most useful approach in a short essay — before sketching in the artist's biography and looking at reproductions of some of his major paintings — is to consider what he said himself about the relation between his art and the world. For, although his painting never corresponded totally with his theoretical writings, he was, nevertheless, the most intellectual of artists who reflected on his creative practice. Thanks to the diary which he kept from 1898 to 1918, to the *Creative Credo* published in 1920, his lecture 'On Modern Art' given at Jena in 1924 and his hefty pedagogical writings at the Bauhaus, we have solid first-hand information about the spirit that motivated his massive and multiform creative achievement.

In his *Creative Credo*, Klee established the premise of his philosophy: 'Art does not render the visible but renders visible.' And he went on: 'Formerly artists represented things that they had seen, enjoyed seeing or would like to have seen. Now the relativity of things is exposed and thus our faith is expressed that the visible world is only an isolated phenomenon in relation to the cosmos and that other realities outnumber it. Objects now appear in an enlarged and diversified form that often seems to contradict the rational experience of yesterday.' In common with many other modern artists, especially those like the Surrealists who also drew on the idealist tradition of German Romanticism, Klee believed that true reality was not

manifest on the surface of things but lay deeper, hidden within them. Art had a responsibility, which was both moral and aesthetic, to deepen our insight into these secrets. The job of the painter was to convey a sense of realities beyond appearances but still rooted in our experiences of the tangible world. Klee compared the artist to a tree: he plunges his roots below into the soil of experience and sensation; above, he exhibits this otherwise secret world in the transmuted but equally ramified forms of foliage. And the themes from the real world which the painter transforms into art are not limited to material objects but include processes, realms of consciousness like dream and memory, the past, present and future, and indeed all formal structures from the biological to the mathematical. In his paintings Klee demolished the distinctions between these various domains and made them interpenetrate and cohabit. Thus time can be suspended, and the sun both rise and set in the same picture (*Insula Dulcamara, plate 33*). We also find the extraordinary encounter of a tom-cat and a magician in *Magic Theatre* (*plate 18*), and the incorporation of a capital letter into the landscape of the *Villa R* (*plate 8*).

The space in Klee's pictures is therefore 'psychological' space, even if it is depicted in the form of structures borrowed from Cubism or Constructivism. Similarly, Klee's images correspond to reality but they do not represent it. It is not surprising, therefore, that he rejected the distinction between 'abstract' and 'figurative' when applied to his art. Klee's pictorial language is that of symbols, the products of what he called 'form-thinking' which seeks to reach beyond the contingent and the ephemeral towards 'totality in the conception of natural objects'. Klee's motifs are thus often open-ended; they suggest rather than define. And the vocabulary of this symbolic language extends from such universal elements as colour and line, to his repertory of more specific signs such as arrows, exclamation marks, circles, hearts and crescent moons. Klee tackles the most grandiose themes in pictures of miniaturistic dimensions, often hardly bigger than a page in a book. Much of our pleasure in Klee comes from deciphering his symbolic language.

Klee's break with the conventions of depicting the material world meant that he turned to a simplified formal vocabulary, to elementary shapes and archetypes, in order to allow the latent and more profound phenomena that interested him to show through. It was this simplification that misled many contemporaries into dismissing his work as infantile, primitive or mad. Although Klee admired the directness and spontaneity of such primitive art, he always distinguished it sharply from his own. He wrote in his diary in 1909: 'If it is true that my work produces at times an effect of primitivism, the explanation lies in the fact that I have disciplined myself to get along with a limited number of levels of reference. It is an economy adopted as an ultimate professional principle, and thus is really the very opposite of true primitivism.'

For Klee, the essence of art and nature alike was movement. Like Bergson and Einstein, Klee saw motion as the basis of all creation, dissolving the distinction between space and time. The picture also springs from the artist's movements, is itself fixed movement and is perceived through the movement of the viewer's eyes. Most of those symbols which we associate most closely with Klee signify some form of desire for change, be it aspiration ('The thought is the father of the arrow. How do I extend the limits of my realm?'), threat, attraction, mediation or biological growth. His pictorial theatre is animated with acrobats and clowns, messengers entering, countless figures walking, dancing and running. His endlessly innovative com-

binations of line, plane and colour are all at the service of movement.

In Klee's view, the emergence of form in the work of art had strong affinities with the process of organic growth in nature. He once described how nascent images issued up out of his unconscious and were allowed to grow according to their own laws: 'The painter, when he is really a painter, forms, or rather, allows forms to arise. He has no intention, no direct one. He is glad to contribute something to the self-forming work, this or that, adding an accent to accents, direction to direction, in order to articulate, clarify, order, stress, emphasize. . . .' Just as he urges the spectator's eye to keep on the move and to explore the picture surface, so Klee would prefer us to try to reconstruct in our minds the process of creation which has given birth to the image rather than to see the latter as a terminal form, a mere product. Werner Haftmann has vividly described the artist in his studio: 'Klee was a tireless worker, but he knew that one must be patient with an image if it is to yield up its meaning. He was busy all day at his work-table, scraping, priming, spraying, dabbing, drawing or hanging up damp sheets of watercolour on a line to dry. All around his studio, on easels and on the walls, were pictures, some begun, some half-finished or almost finished, but each with its own troubles and demands. Klee moved among them like a magician, going from one to another listening attentively to the requests of each.' Only at the end, when the 'thing in the course of forming' had become visible as a figuration, would Klee 'christen' his picture. The title, often a fragmentary prose-poem in itself, might be an analogy identifying what were to Klee the salient motifs in the work.

Paul Klee was born at Munchenbuchsee, near Berne, on 18 December 1879, into a cultured, musical family. His father, who came from Bavaria and kept his German nationality, taught music at the local teachers' college. His mother was Swiss and had lived some time in France. In these favoured surroundings, Klee received a broad classical education and soon showed himself to be a gifted poet, violinist and artist. As an adolescent, he played in the Berne municipal orchestra and remained a practising musician thereafter as well as an avid concert- and opera-goer. Although at nineteen Klee already referred to himself as 'a future painter', his feeling for music, which he loved less as expression of sentiment than as harmonious intellectual structure, was to be reflected throughout his art.

For his art training, Klee chose Munich, the city of the Secession and of Jugendstil, rather than Paris. His choice suggests that he already gave a Germanic priority to the spiritual and the inner vision over the retinal approach to reality of the Impressionists and the Ecole de Paris. Klee's period of formal art study — private lessons, the Academy under instruction from Franz von Stuck, eleven months in Italy — saw him trying to make his peace with the classical tradition. In Italy, he found the life of modern ports like Genoa and the aquarium at Naples more congenial than the daunting artistic legacy of the Renaissance. His first major work, a series of sardonic and grotesque satirical etchings, executed in Berne between 1903 and 1905, was his way of exorcizing the oppressive spirit of the classical heritage and opening up the way to a new, less literary, pictorial freedom. In 1906, Klee returned to Munich to marry Lily Stumpf, a distinguished musician, and in the following year their only child, Felix, was born. The Munich artistic scene was much more lively now than during his previous stay — Wedekind and Alfred Kubin were there, as well as the future Dadaists, Hans Arp and Hugo Ball, and the Russian expatriates, Kandinsky and Jawlensky. Major exhibitions of Post-Impressionism introduced Klee to Cézanne, Matisse, the Fauves and the Cubists.

Although Klee had been methodically educating himself in the use of colour for many years, it was as a graphic artist that he was known prior to the First World War. He exhibited etchings and drawings with the 'Blauer Reiter' group in 1912 and with these works began to make his first sales. If he refused for so long to regard himself as a painter, this was because he had set himself such a high twofold ambition. First, he aimed to reconcile the innocence of the visionary with orderly, structural discipline, or, as he put it in his Diary in 1902: 'My immediate and highest goal is to bring architectonic and poetic painting into a fusion.' Secondly, he aimed to integrate his command of drawing with the use of colour. Painting based on disciplined improvisation was to be his alternative to fidelity to conventionally observed nature. He took up clues from Matisse, Cézanne (*Girl with Jugs*, plate 2), the Cubists and his fellow 'Blauer Reiter', Kandinsky, as to how, having set aside the canons of objective representation, to exploit the structural and emotional potential of colour. Most significant of all these influences for Klee, perhaps, was the pictorial theory of Robert Delaunay. Klee had met the 'Orphist' painter in Paris in April 1912 and later that year translated Delaunay's essay 'On Light' for publication in the review *Der Sturm*. Delaunay argued that painting, if it was to achieve 'the sublimity of nature', should renounce the representation of objects and the treatment of reflected light and that its proper subject should be the relationships between colours themselves. Delaunay held out the enticing possibility of a 'pure painting' subject to its own laws analogous to those of musical composition.

In 1914, Klee at last found his independent path as an artist. The experience which transformed the patient, eclectic searcher into a painter confident of his mastery of colour was the visit he made to Tunisia, in the company of his friends Louis Moilliet and Auguste Macke, in April of that year. Inspired by the brilliant light of a landscape out of the *Thousand and One Nights*, Klee transposed the architecture of Kairouan and Hamammet (*Red and White Domes*, plate 3) into a translucent interplay of floating rectangles of colour in an overall pattern of shifting planes and perspectives. Feeling overcharged with ideas, Klee hastened back to Europe so as not to lose his creative momentum. Over the next few years, he perfected his own version of the pictorial language of Cubism so that it became a vehicle for his personal brand of German Romanticism, exemplified in the long series of magical, scintillating watercolours that Will Grohmann has called Klee's 'cosmic picture-book' (*The Niesen*, plate 5). Even the First World War failed to stem Klee's creative flow. His service in the German army was behind the lines. He was detailed to repair and camouflage aeroplanes and these structures kept finding their way thereafter into his paintings as mechanical birds and bizarre formations which float like kites.

By 1920 Klee had achieved a measure of international recognition and the first monographs on his work appeared. In November, he accepted an invitation from Walter Gropius to join the staff of the recently-founded Bauhaus at Weimar. Unlike a normal art school, the Bauhaus laid special emphasis on the common roots of the fine arts in design and the crafts. Klee was nominally attached to the departments of glass and weaving but his main teaching contribution was an advanced course in the theory of form. As an artist who always sought to illuminate practice with theory, Klee found his teaching especially rewarding since it heightened his awareness of his own working methods.

Klee's students at the Bauhaus found him kindly but reserved. Surrounded by an aura of benevolent wisdom, he had the habit of tingeing his

comments with gentle sarcasm. Never dogmatic, he spoke in pithy aphorisms which were suggestive but preserved the mystery of the creative problems at issue. His prodigious output in the 'twenties – he accompanied the Bauhaus when it moved to Dessau in 1925 – shows that he found teaching a stimulus rather than an interference. The aesthetic atmosphere of mediaeval Romanticism mingled with Socialism which prevailed in the first years of the Bauhaus congenially matched the mood of fantasy in Klee's own work of 1920–23 (*God of the Northern Forest, plate 14*, and *Magic Theatre, plate 18*). Among the factions which increasingly divided the Bauhaus staff, Klee was usually an unaligned element. His position became more peripheral after the appointment of Moholy-Nagy signalled the ideological reorientation of the Bauhaus towards more rationalistic, industrial functionalism. Klee went along to some extent with the dominant current of ideas at the Bauhaus, as is shown by his evolution away from Cubism towards Constructivism (*Hovering – before the ascent, plate 27*), which was paralleled by his shift away from highly personal, romantic motifs towards an imagery reflecting more general, objective concerns. But he found that the in-fighting at Dessau was having an increasingly disruptive effect on his work and in 1931 gladly accepted the offer of a part-time professorship at the Düsseldorf Academy of Fine Arts. A few years previous to this, in the winter of 1928, his creative vision had been stimulated by a second oriental experience, this time a visit to Egypt. In the compositions of piled-up horizontal layers of colour through which Klee conveyed his sense of Egypt's expanse in space and time (*Monument in a Fertile Country, plate 25*, and *Main Road and Side Roads, plate 24*), he carried a stage further the condensation and abbreviation characteristic of his later work, and produced some of his most vigorously beautiful and vibrant paintings.

Klee's teaching career came to an abrupt end when he was dismissed from his post at the Düsseldorf Academy after Hitler came to power in 1933. To the Nazis, Klee's art was the epitome of decadence. Later, over a hundred of his pictures were removed from Germany's public collections and put up for auction. At the end of 1933, Klee returned to Berne where his father and sister still lived. Although the loss of his teaching job was not too serious a blow because he was now well able to make a living from his art alone, and in any case the Klee's had always preferred to live modestly, the circumstances of the upheaval were traumatic and were aggravated by the refusal of the Swiss authorities to grant citizenship to Klee. His painting was still more seriously interrupted in 1935 by the onset of sclerodermia, a disease which dries up the mucous membranes and calcifies the tissues, and which was to cause his death five years later. Only in 1937 did Klee overcome the depression caused by these reverses and start work in earnest again.

The paintings of the immensely fertile last three and a half years of Klee's life differ markedly in a number of ways from his previous work. Many of the late period canvases are monumental in scale, in contrast to the intimate format of earlier years. His line has also become weightier, more deliberate, and lost much of its nonchalant spontaneity. The composition has become starker, drawn in thick, black lines, often on coarse canvas, sometimes with the pigment rubbed rather than painted on. Klee's humour still flickers but with a bitter and ironic emphasis. Although he continued to explore the possibilities of new media – pastel, for instance – in his large horizontal panels of 1937 and 1938, he abandoned his programmatic experiments with colour (*Ad Parnassum, plate 29*) in favour of a more graphic and per-

sonal expressionism. In the sequence of sonorous works illustrated here by *Overland* (*plate 31*), *Insula Dulcamara* (*plate 33*) and *Park near Lu(cerne)* (*plate 34*), we no longer find solid objects defined by line but rather pictures constructed out of discrete linear elements distributed across the entire picture surface. These bars and lines become signs in their own right which we may recognize as ideograms for trees, flowers, heads and the edges of fields.

Treatment proving ineffective, Klee's illness continued its inexorable advance towards the heart. His effort to come to terms with approaching death is vividly reflected in his figurative expressionist works of 1939 and 1940, illustrated here, for example, by *Mask* (*plate 37*), *Death and Fire* (*plate 38*) and *The Cupboard* (*plate 39*). Klee wrote to Will Grohmann: 'Naturally I haven't struck the tragic vein merely by accident. Many drawings point that way and say, "the time has come".' As might be expected of him, Klee imagines the fate in store for the soul as a kind of drama played out by angels and demons who have taken the place of his puppets and clowns from the 'twenties. These figures are usually presented close up, monopolizing the picture space, leaving us no option but to confront them and try to stare them out. Klee himself faced death without self-pity and without illusions. Frightening as these spectres are, the beholder is in little doubt that Klee had taken their measure. He died at the Sant'Agnese Clinic at Muralto-Lugano on 28 June 1940.

1. *Garden Scene with Watering-Can*

1905. Watercolour on glass. $5\frac{1}{8} \times 7\frac{1}{8}$in ($13 \cdot 1 \times 18 \cdot 1$cm)

Despite their diversity, the works of Klee's mature style are so easily identified and so inimitable that the uninitiated might imagine them to be *sui generis*. In fact, Klee was very slow-maturing as an artist and his formation was influenced to some degree by most of the modernist movements in European painting. This is one of a series of twenty-six drawings and watercolours done on glass in the period 1905–6. The bright colours and linear arabesques are reminiscent of Matisse although there is no evidence that Klee had seen Post-Impressionist or Fauvist work on his first visit to Paris in 1905.

Berne, Collection Felix Klee

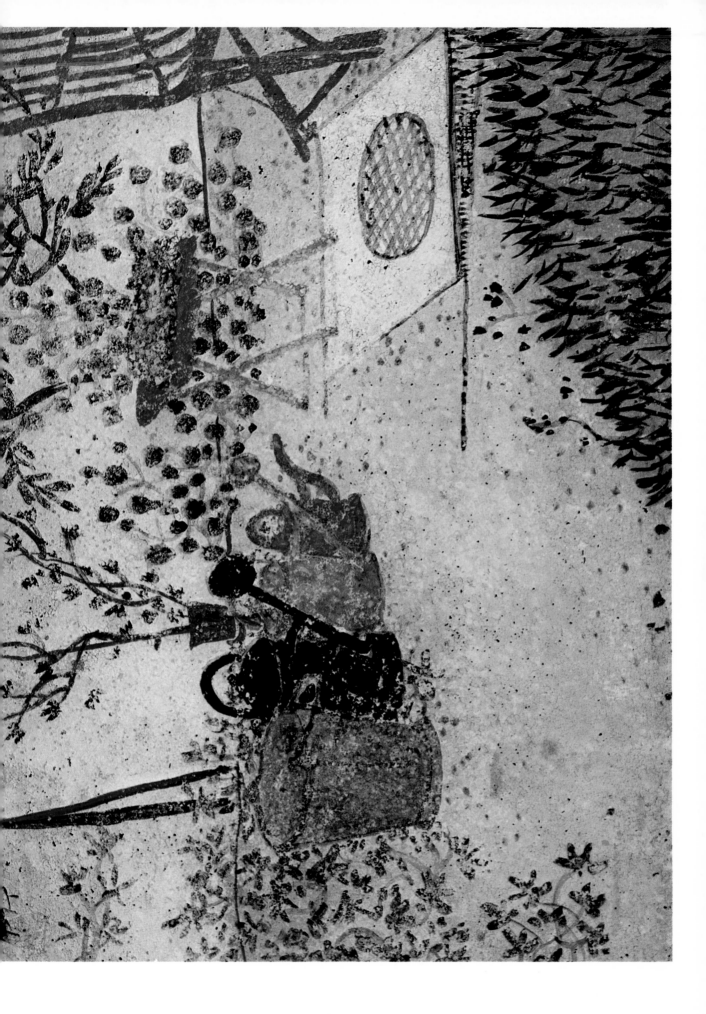

2. Girl with Jugs

1910. Oil on Panel. $13\frac{1}{2} \times 10\frac{5}{8}$ in ($34 \cdot 5 \times 27$ cm)

This is one of the most obviously Cézannesque paintings of Klee's early development. It was the optical, impressionist and colourist qualities in Cézanne's work that appealed most directly to Klee, and in particular the French painter's stress on the constructive power of colour which can replace scientific perspective. Like Cézanne's pictures, the structure of Klee's paintings was henceforth to be on the surface. Cézanne's example was critical in helping Klee to break out of the established pictorial conventions for rendering objective reality and to establish new ways of depicting nature.

Berne, Collection Felix Klee

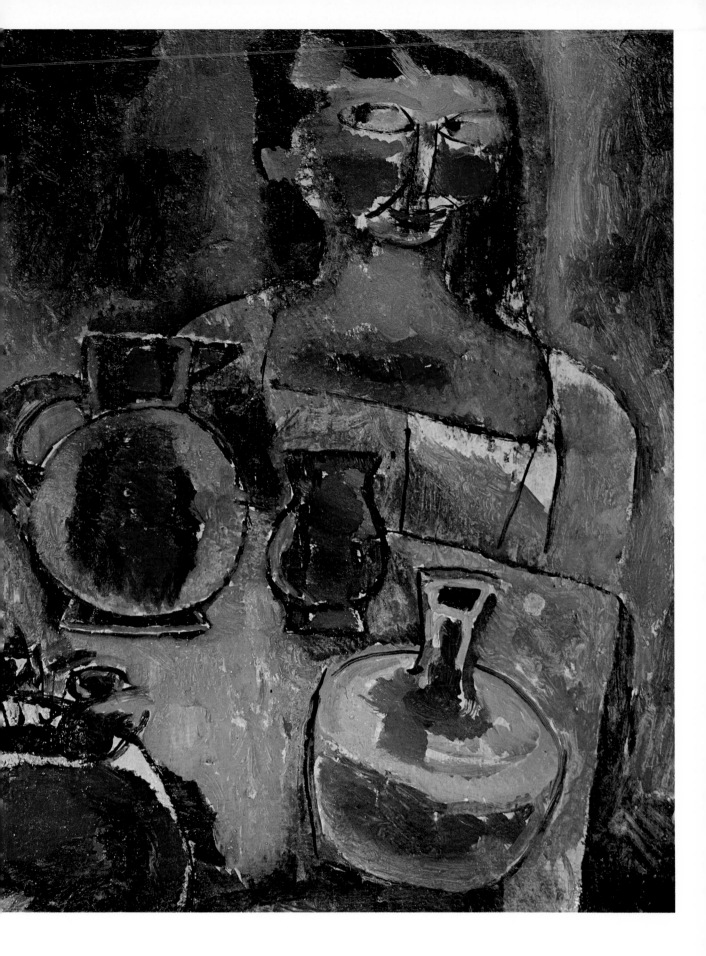

3. *Red and White Domes*

1914. Watercolour. $5\frac{1}{2} \times 6in$ (14 × 15cm)

In his diary entry for 16 April 1914 during his stay at Kairouan, Klee wrote ecstatically: 'Colour has taken hold of me. I need no longer strive after it. It has taken hold of me once and for all. . . . I and colour are one. I am a painter!' In his own eyes, at thirty-four, his long apprenticeship was over. Klee was in Tunisia a mere twelve days but the lessons which he drew from his experience of the intense African colour and translucent light were to transform his life and work. In the pictures done in North Africa or, like this one, from memory on his return to Europe, he was bent on achieving what he called 'the synthesis of urban architecture and pictorial architecture'. The characteristic features of the Arab town are there, but built up in the flat, in a carpet-like fabric of contrasting colours set in rectangles and semicircles.

Düsseldorf, Kunstsammlung Nordrhein-Westfalen

Klee

Rote u. weisse Kuppeln 1914.45.

4. *Abstraction: coloured circles with coloured bands*

1914. Watercolour. $4\frac{1}{2} \times 6\frac{3}{4}$in (11·5 ×17cm)

In the paintings inspired by the Tunisian experience, form for Klee had already become almost an accident of colour. In this abstract watercolour, Klee appears to be once again indebted to Robert Delaunay, whose treatment of light and colour in the series entitled *Windows* had prepared the way for Klee's North African pictures, and who had since moved on to pure abstraction, employing circular forms. The spatial dimension of this composition emerges out of the rhythmic contrasts between the elementary geometrical forms.

Berne, Paul Klee Foundation

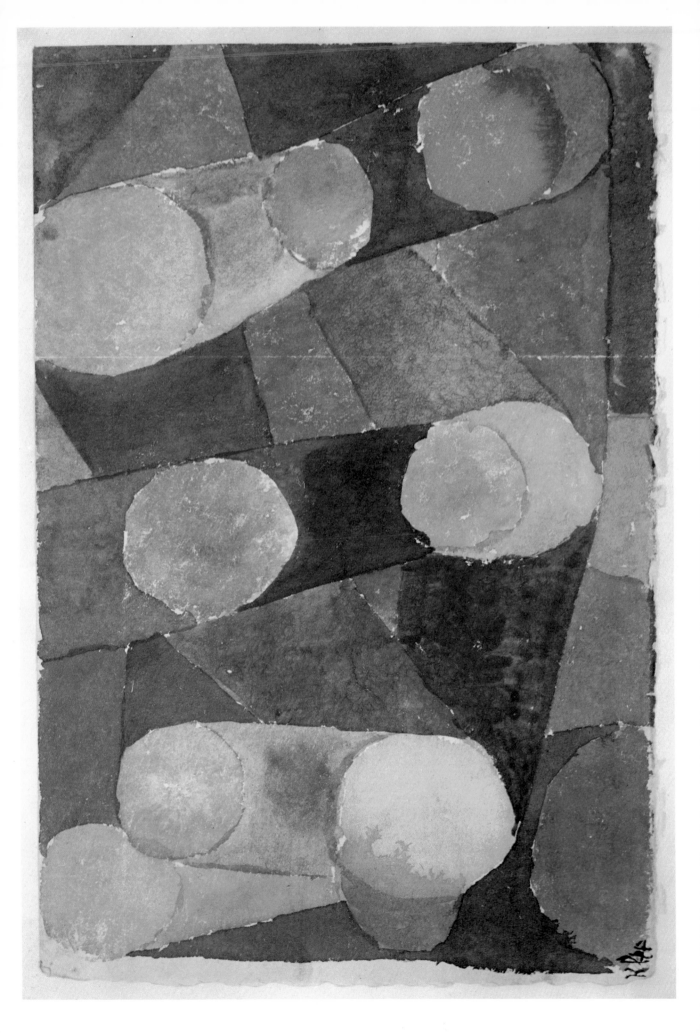

5. *The Niesen*

1915. Watercolour. $7\frac{1}{8} \times 10\frac{1}{4}$in $(18 \times 26cm)$

Klee continued to paint in coloured rectangles, but the pictures of 1915 and the immediately succeeding years generally have more stable compositional structures and tend to become flatter and less jumbled. Here the peak in the Bernese Oberland has become a magic mountain. Above it hang a cluster of celestial folk-symbols: cosmic signs such as the quarter-moon, the six-pointed star and asterisks. Europe was now at war and Klee's friend Macke had been killed in the first weeks. In the singing blue of his pyramid, Klee seems to be asserting the supremacy of poetic values over those current in the world beyond the Alps. He was to write in his 'Creative Credo' in 1920: 'Symbols reassure the mind that we do not depend exclusively on mundane experience'.

Berne, Hermann and Margit Rupf Foundation

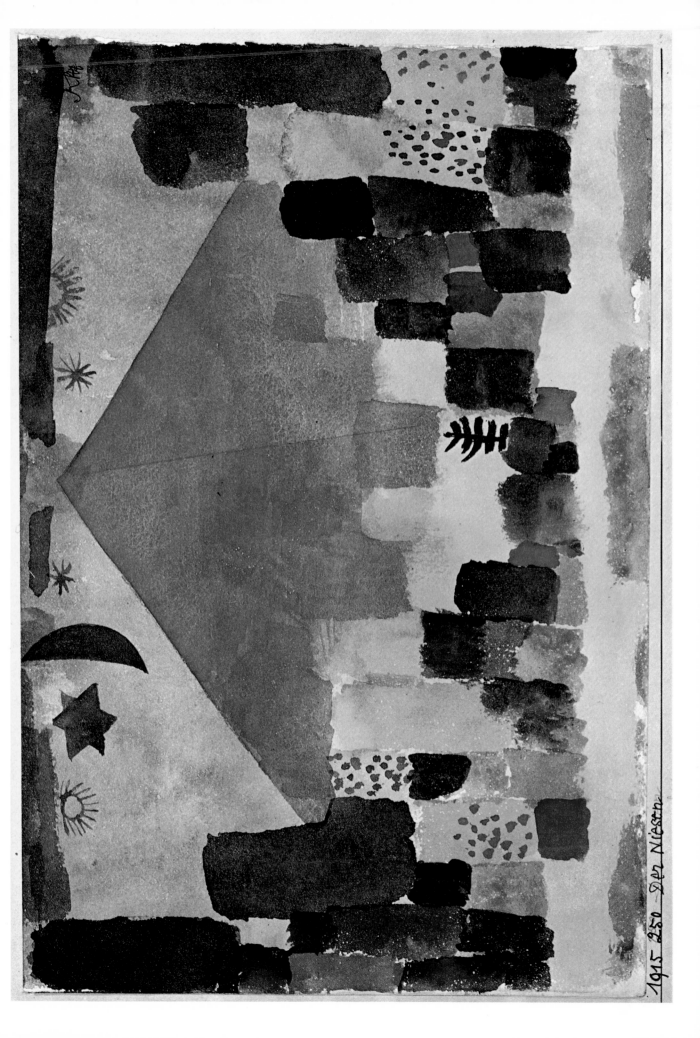

1915 250 Der Niesen.

6. *City of Towers*

1916. Oil on wood. $12\frac{3}{4} \times 14in$ ($32 \cdot 5 \times 35 \cdot 5cm$)

The theme of a tall city was a favourite one with Klee. It was often endowed with the mystical or fantastic quality of a Jerusalem, Parnassus or Valhalla. Here the gate and the path in the foreground on the left suggest the necessity of a journey complete with ordeals which must be undergone before the pilgrim may enter the city gates. The simple all-over pattern of small geometric shapes looks forward to the many 'magic square' paintings from 1923 onwards.

Philadelphia, Museum of Art

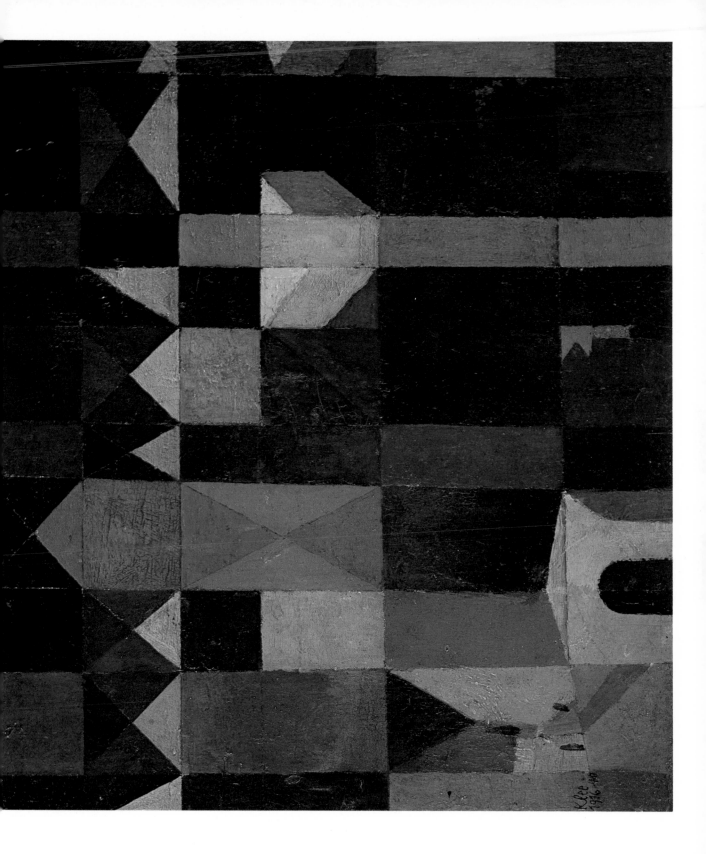

7. Demon over the Boats

1916. Watercolour and pen on paper, on cardboard.
9 × 8in (23 × 20cm)

Symbols of the malign proclivities in man's nature and
of the forces of destiny that preside over both human and
natural life are to be found throughout Klee's work.
But his demons and witches are usually treated with
irony; terror is mitigated by wit. Here the flapping
articulated planes of the demon's wings and the
squirming, scroll-like forms that make up his body
express his destructive energy but, at the same time,
show him to be as transparent and insubstantial as the
harbour he threatens. Klee believed that men should
strive to make a synthesis between the demonic and the
angelic forces within them. As he wrote in 1917:
'Something new is in preparation; the diabolic forces
must be merged with the heavenly forces, and dualism
must not be taken as such but as embracing the
complements of oneness.'

New York, Museum of Modern Art

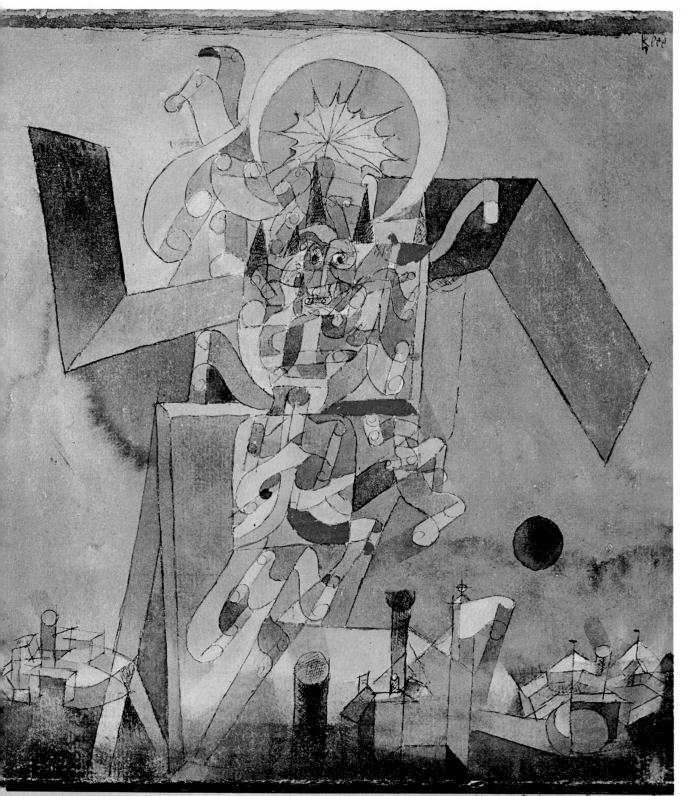

1916 - 65. Dämon über d. Schiffen

8. *Villa R*

1919. Oil. $10\frac{3}{8} \times 8\frac{5}{8}$in (26·5 × 22cm)

In 1919–20, Klee produced a series of small landscapes in oil composed primarily of architectural elements such as walls, roofs, towers and windows. They are richly-painted, luminous works, glowing with an inner, nocturnal light. In this tightly structured example, Klee also incorporates a green capital letter 'R' which echoes the shape of the house and is in turn balanced by the quarter-moon of the same colour in the top left-hand corner. Georges Braque had been the first to insert letters and numbers into his pictures in 1912, but the cubist painter's purposes were primarily formal, whereas with Klee, they are poetic. Like the Chinese who associate calligraphy with painting, Klee also sought to reconcile nature and script. Thus the signs, letters, numbers, exclamation marks, crosses and their like that abound in Klee's work have largely been divested of their function as instruments of communication in the everyday world and stand rather as images in their own right.

Basel, Kunstmuseum

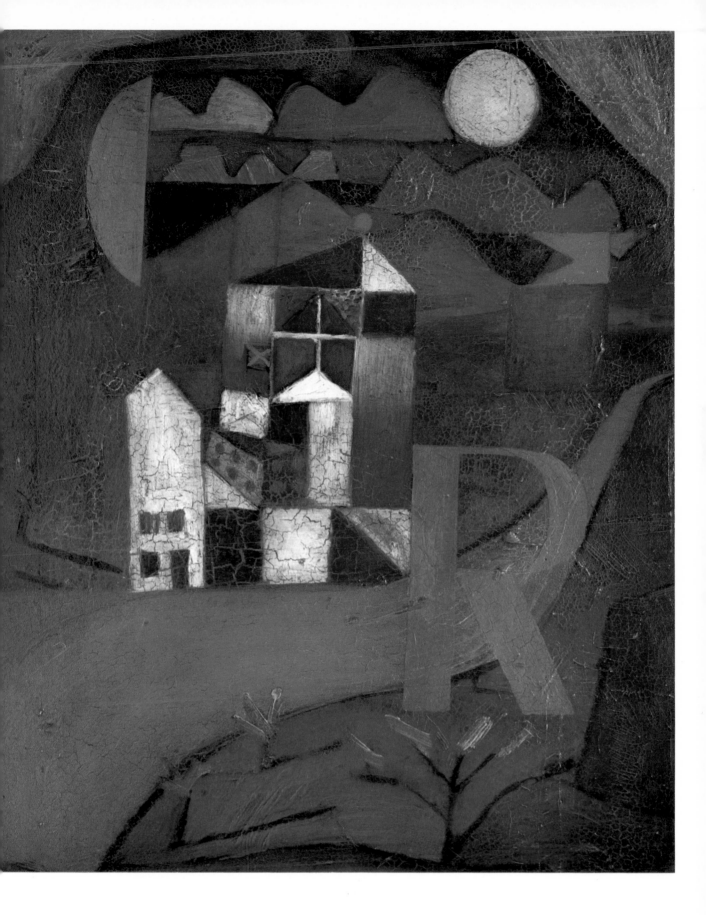

9. *Self-Portrait (lost in thought)*

1919. Lithograph. $10\frac{1}{2} \times 7\frac{1}{8}$in (26·5 × 18cm)

Legend had it in the Klee household that ancestors on his mother's side came originally from North Africa. This might explain in part the pronounced spiritual affinity between the work of Klee and Oriental art. The Moorish features which struck so many of his contemporaries are very evident in this lithograph self-portrait. Of his portraiture in general, Klee wrote: 'Many people will not recognize the truthfulness of my mirror. They should remember that my purpose is not to mirror the surface (the photographic plate can do that) but to penetrate to the interior. I mirror right to the heart. I write the words on the forehead and around the corners of the mouth. My human faces are more truthful than the real ones.' Klee draws himself with eyes closed. A few years later the Surrealists in Paris had their photographs taken also with eyes closed. Like them, Klee searched for a reality which is to be observed with the inner eye.

Berne, Collection Felix Klee

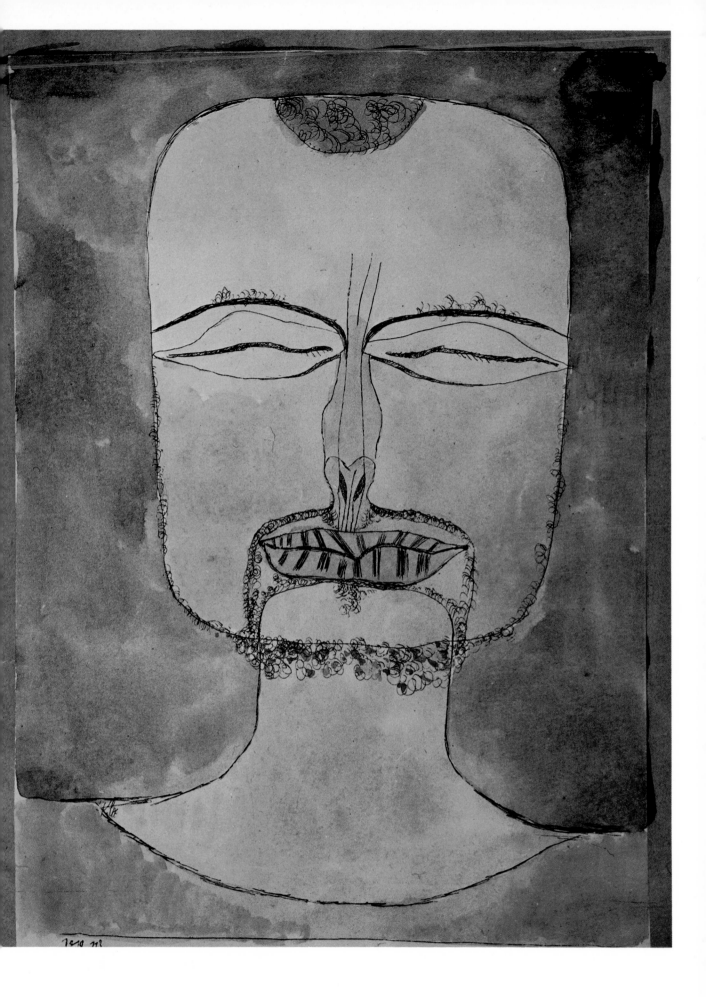

10. *Landscape near E (in Bavaria)*

1921. Oil on paper on cardboard. $19\frac{3}{4} \times 12\frac{3}{4}$in (50 × 35cm)

This painting dates from the period immediately
following Klee's appointment to the Bauhaus, during
which he still lived at Munich and commuted to Weimar.
As in *Villa R* (*plate 8*), painted two years earlier, Klee has
here formally absorbed an alphabetical symbol into the
pictorial landscape. He refers to the letter again in the
punning title. Numerous elements deliberately contradict
the notion of distance and spatial depth in this image of
a wooded landscape. The ascending planes, scrolls and
intersecting lines compose a structure which is shallow,
the reds and blues have a close-up intensity, and the fir
trees are so many arrow-signs on the surface. Klee's
concern with the edges of his pictures is evident in the
surround, which, with the sash-window cross-piece,
further emphasizes the two-dimensionality.

Berne, Paul Klee Foundation

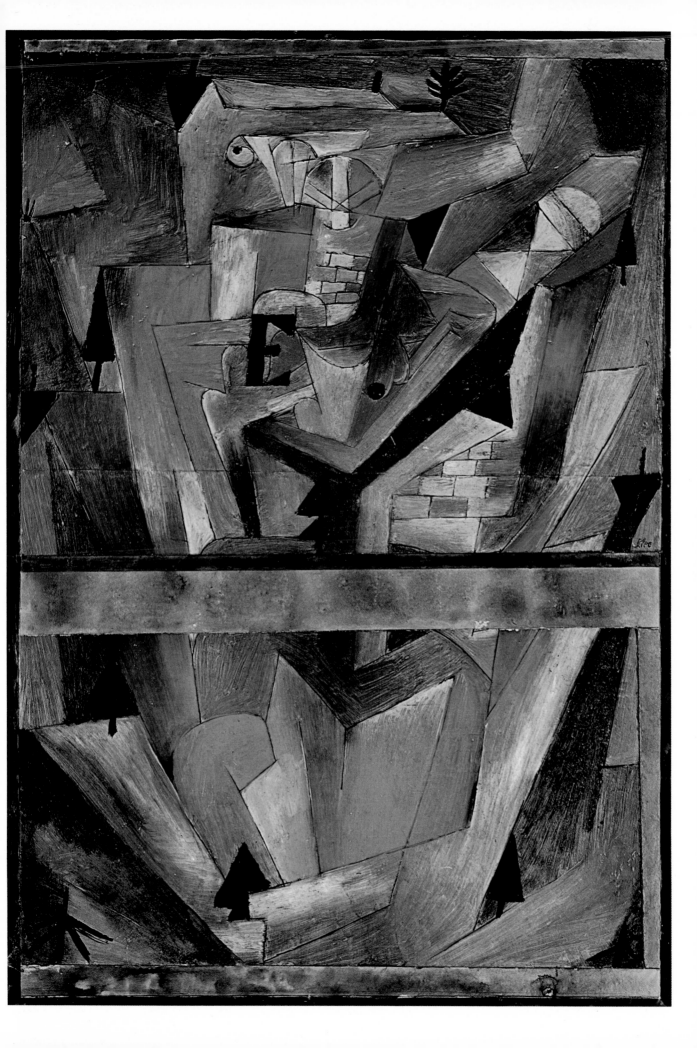

11. *Greeting*

1922. Watercolour. $8\frac{3}{4} \times 12\frac{1}{2}$in (22·2 × 31·4cm)

During his Bauhaus period, Klee was intent on simplifying his pictorial means. Dispensing with all narrative and representational content, Klee has reduced his image to a rigorously formal system of horizontal layers, to emphasize better the power of the colours themselves. The arrows serve both as directional symbols in space and to intensify the step-by-step gradations of violet-to-grey and red-to-pink. They also accelerate the movement from the top downwards and from the bottom upwards, making for the encounter which prompts the 'greeting'.

Hartford, Connecticut, Wadsworth Atheneum (Ella Gallup Sumner and Mary Catlin Sumner Collection)

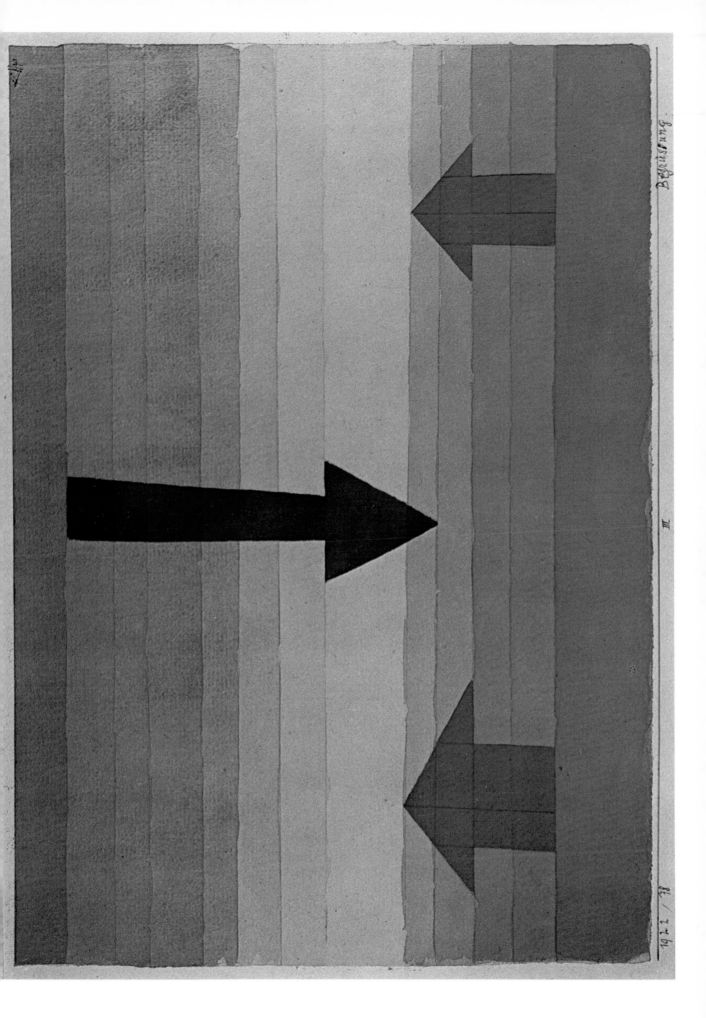

Begrüssung

III

1922 / 78

12. *Growth of Nocturnal Plants*

1922. Watercolour

For Klee, movement was the essence of life throughout
nature. 'Rest', he said, 'is an accidental obstruction of
matter.' So for him a still life had nothing to do with
nature morte. He was not interested in illustrating these
plants as finished forms but in expressing the dynamics
of their growth. He achieved this here by the rhythmic
superimposition of simple units of alternating colour.
Starting from a 'bed' of black, each plant goes through
the same colour cycle of growth stages: neutral grey to
cold blue at the base of the stem, then from light grey to
orange, and finally from grey to a cool, whitish-blue at
the head.

Munich, Stangl Gallery

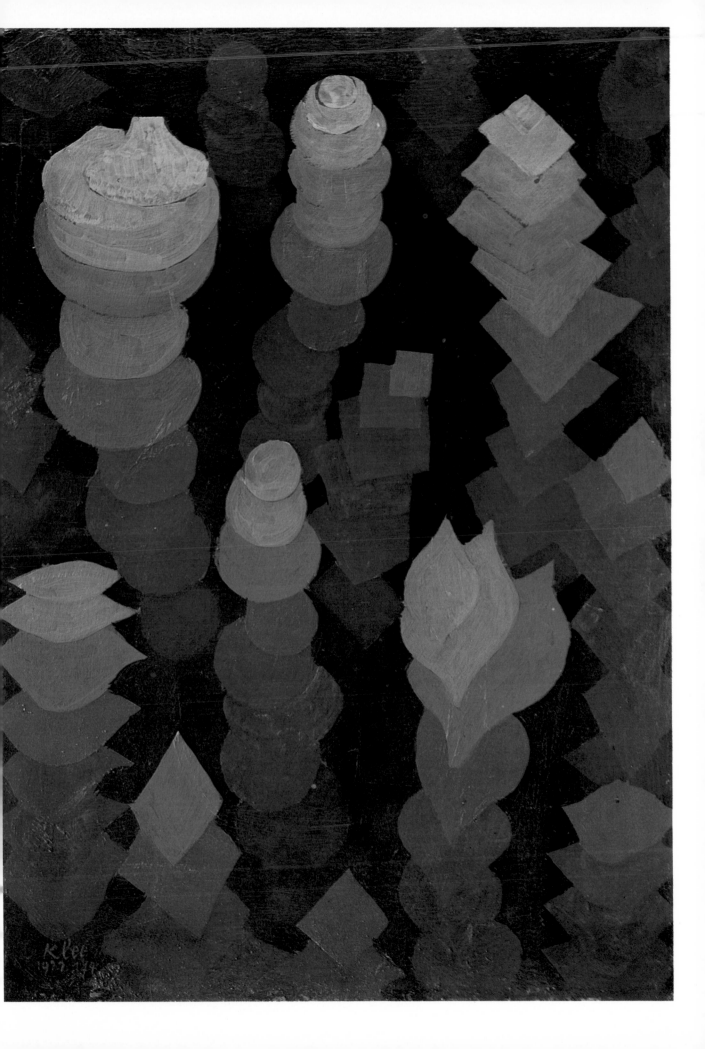

13. *Vocal Fabric of the Singer Rose Silber*

1922. Gouache and Gesso on Canvas. $20\frac{1}{2} \times 16\frac{1}{2}$in (52 × 42cm)

Like many painters at the time, Klee was very interested in analogies between painting and music, both of which he believed to be temporal arts. In order to explain some points of pictorial theory to his Bauhaus students, he translated a passage from a Bach sonata into graphic terms. The aim in this enigmatic picture seems, however, to have been more poetic than analytical. The singer's initials and the vowel sounds lie transparently on a rough surface of thick gesso. The delicate green and white 'voice cloth' is itself stretched out like a parchment on a pink ground. It is a 'fabric' worn at the edges, with varying degrees of smoothness and thickness, and acts as a pictorial metaphor for the texture of a voice.

New York, Museum of Modern Art

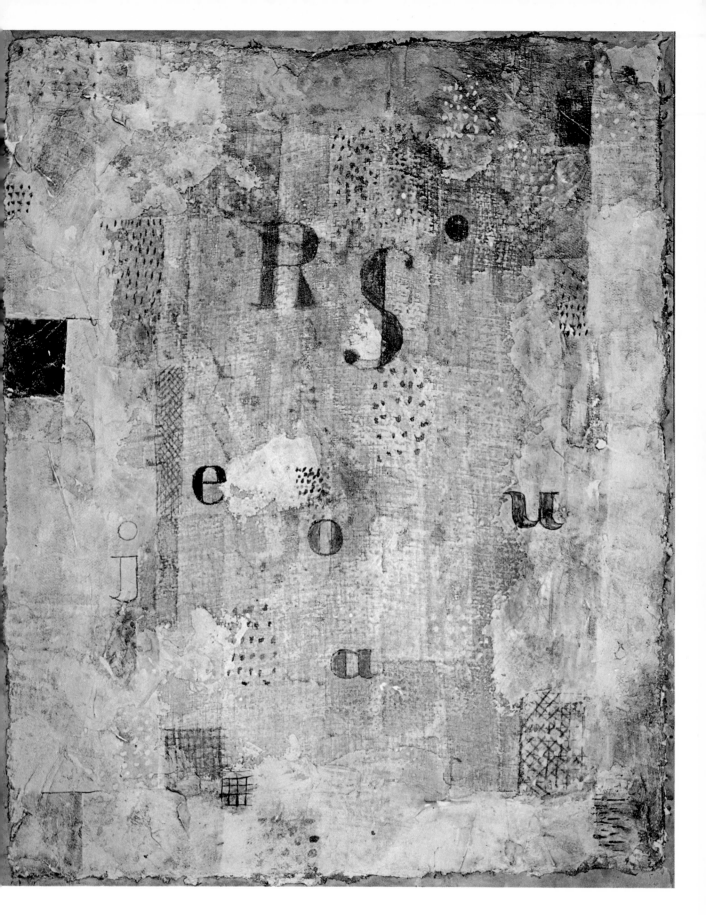

14. *God of the Northern Forest*

1922. Oil on canvas on cardboard. $20\frac{7}{8} \times 16\frac{1}{2}$in (53 × 41·2cm)

For Klee, myth — together with states of mind or emotion, the hidden processes of natural growth and decay, the abstract disciplines of mathematics and geometry — was as much a subject for the painter as the appearances of the outside world. Similarly, he had no hesitation about introducing ancient things into the company of modern, or intermingling the fictional with the real. Here we see the awesome visage of the pagan deity both emerging from and residing within the stratified transparent planes of the trees which are his forest home.

Berne, Paul Klee Foundation

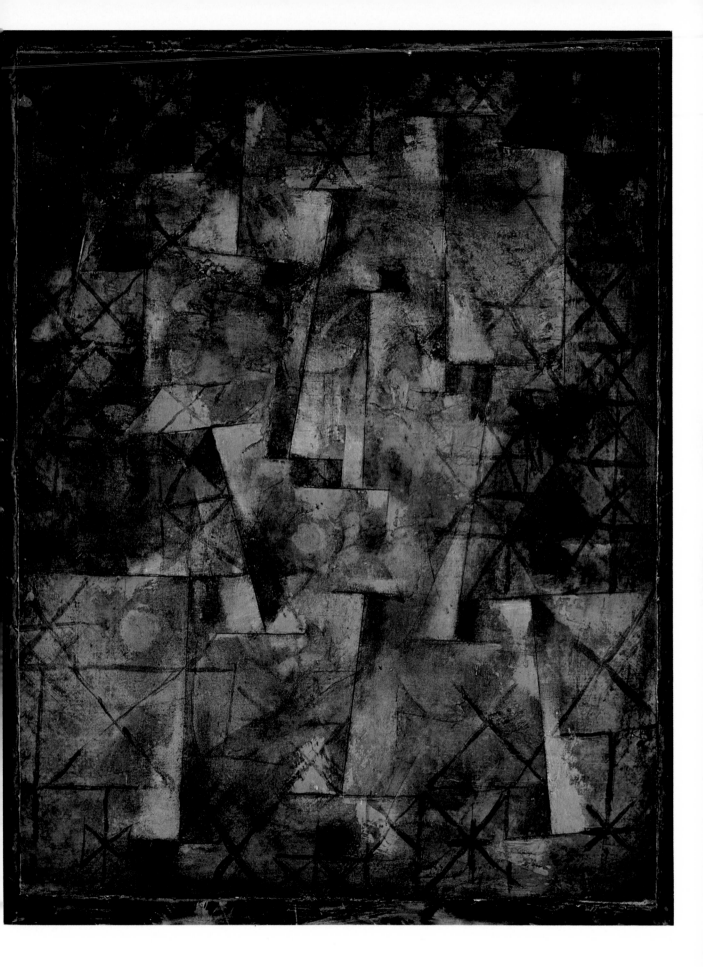

15. *The Twittering Machine*

1922. Watercolour and oil drawing. $16 \times 11\frac{3}{4}$in
(40·6 × 29·8cm)

This is 'quintessential' Klee in that it exemplifies the playful fantasy and witty, economical use of line that have made Klee one of the best-loved of twentieth-century modernist artists. Like the Dadaists, Marcel Duchamp and Francis Picabia at about the same time, Klee found a rich source of humour in the machine. He much enjoyed the effects obtained by animating the inanimate and mechanizing the living, or, as here, leaving the beholder uncertain which is which. In a drawing of 1921 entitled *Concert on a twig*, the four bird-like creatures were perched on a branch; in this picture, the branch has been changed into a crank turned by a handle, as in a musical box.

New York, Museum of Modern Art

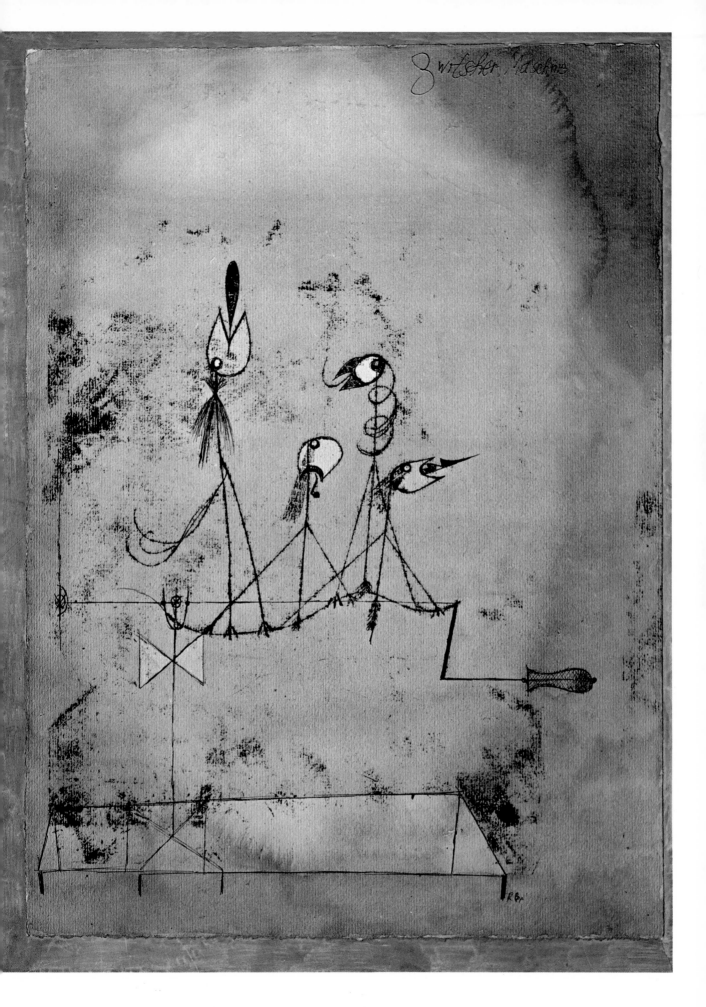

16. *Young Girl's Adventure*

1922. Watercolour. $17\frac{1}{4} \times 12in$ (43·8 × 30·8cm)

The carnal aspect of love seldom appears in Klee's work.
Rather it is sublimated into a more universal energy
drive such as the formative urges of natural growth and
the dynamics of attraction. The erotic references in the
watercolour opposite, which belongs with his series of
'colour-gradations', are unusually direct for Klee. The
zigzagging arrow in brilliant red indicates the nature of
the young girl's adventure, further emphasized by the
red sex of the woodland creature in the left-hand corner
of the foreground. The silhouette of the maiden, with its
elongated head and intricately flowing ornament, seems
to have been based on a Wajang shadow-play figure
from Javanese puppet-theatre.

London, Tate Gallery

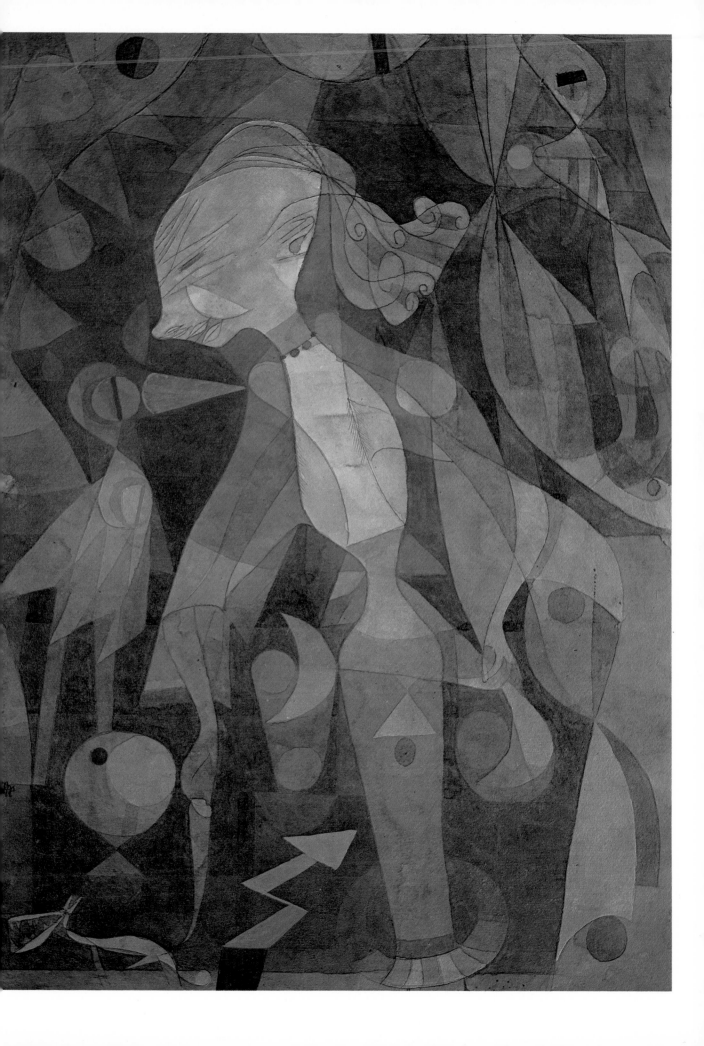

17. *Senecio*

1922. Oil on linen. 16 × 15in (39·8 × 38cm)

Klee's work, perhaps more than that of other moderns, has time and again provoked the angry comment: 'A child of eight could have done it!' Klee would have replied that it was his own disciplined simplicity based on hard-won professional experience that gave his work its primitive or childlike appearance. In *Senecio*, Klee employs the most elementary geometrical forms of circle and rectangle, albeit freely drawn, to outline the frontal head. The sharply-drawn eyes resemble a pair of fish swimming in a bowl. Yet Klee's vision of the life latent within simple forms is so clear that an intense, if enigmatic, human portrait results. In accordance with Klee's ideal of the 'fraternization' of all species of created life, the title refers to a genus of plant. Klee was no doubt drawing the viewer's attention to the resemblance between shapes in the picture and the flower- and seed-heads of the cineraria, for instance.

Basel, Kunstmuseum

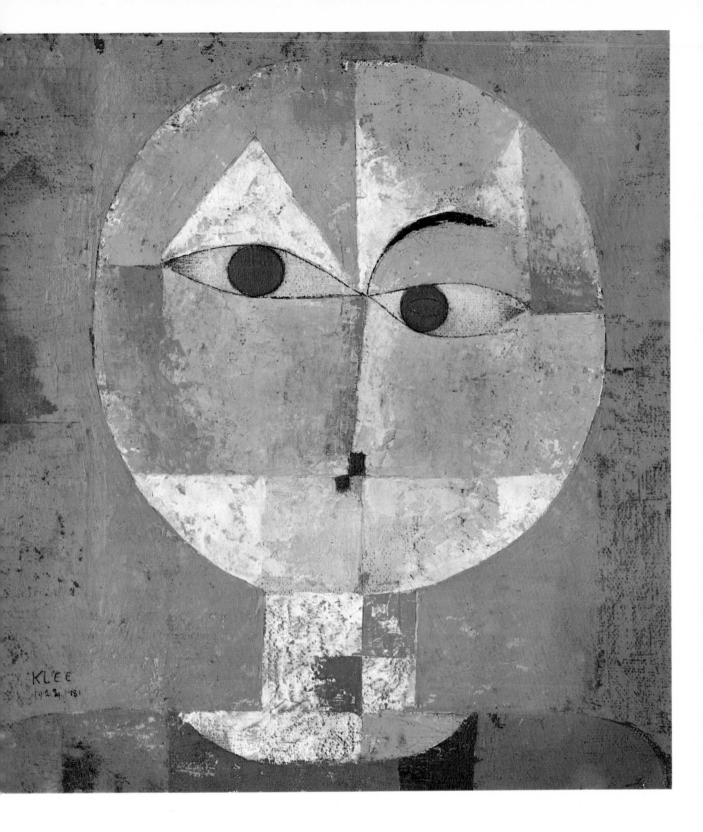

18. *Magic Theatre*

1923. Watercolour. $13\frac{1}{4} \times 9in$ (33·7 × 22·6cm)

Klee did not allow the increasingly functionalist aesthetic of the Bauhaus to subdue his fantasy. According to Christian Geelharr, this scene, which is as peopled with monsters and portents as a painting by Bosch or Bruegel, was inspired by a fairy-tale, *Princess Brambilla*, by the Romantic writer E. T. A. Hoffmann. Against a backdrop of night, the magician produces a pair of dancing homunculi, apparently from a chemical flask. Beside him, on a table at the right, stands a one-eyed four-legged creature of Klee's private imagining. On the left, the head of the enchanter has merged with that of an intervening tom-cat. In the form of a stroke of lightning, the arrow announces the presence of supernatural forces.

Berne, Paul Klee Foundation

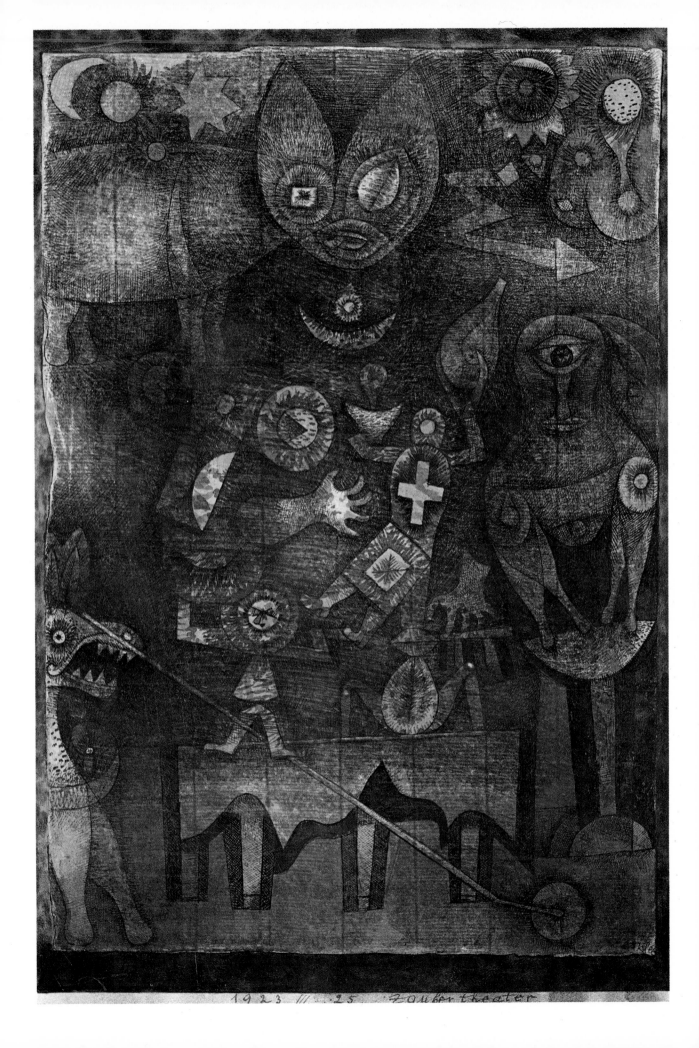

1923 III 25 Zaubertheater

19. *Actor*

1923. Oil. $18\frac{1}{8} \times 9\frac{3}{4}$ in ($46 \times 24 \cdot 8cm$)

As a highly coloured, alternative world of movement and symbolic action, the theatre in all its forms had an irresistible appeal for Klee. Wherever he lived, he went frequently to the opera and ballet. With his little son Felix, first in the kitchen of their Munich apartment, then at Weimar, he constructed marionette theatres and wrote puppet plays. It is hardly important whether this 'actor' is a puppet or whether we are looking at a mask or a caricatured head. This luminous military figure from the depths of the unconscious confronts us four-square and, in him, Klee celebrates the power of the theatre to conjure up tangible demons.

Berne, Collection Felix Klee

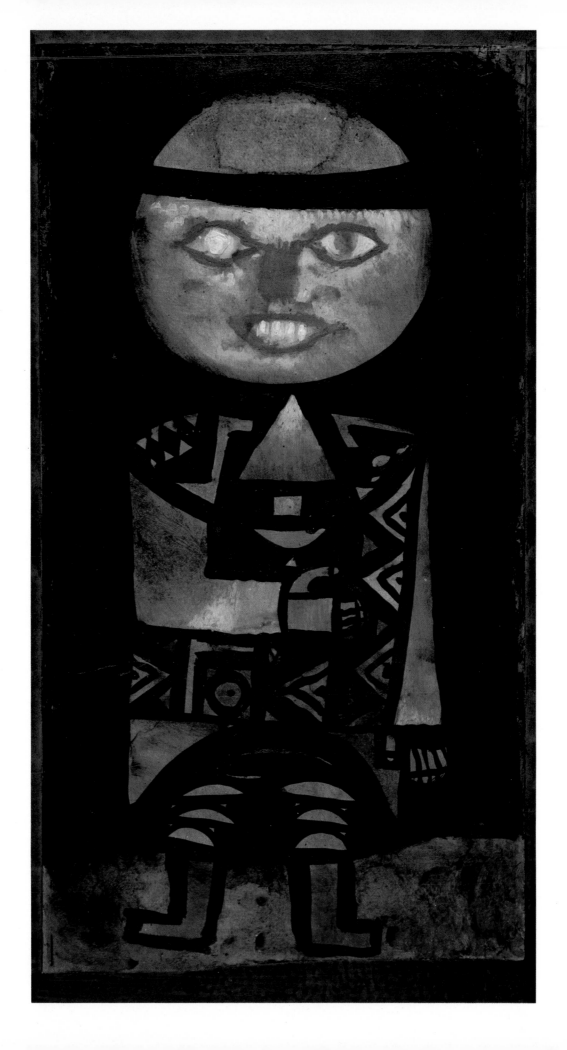

20. *Mountain Carnival*

1924. Watercolour. $10\frac{1}{2} \times 13in$ (26·3 × 33cm)

Like *Magic Theatre* which was painted in the previous year, this is another crowded, phantasmagoric composition in the Hoffmannesque mood. It is similar also in its use of a graphic technique of cross-hatching. Many of the contours have an outline rather like fur or iron filings in a magnetic field. The direction of the tiny lines of the outline, its prickliness or smoothness, depth or lightness, enhances the power of the design and imparts a shimmering quality to the dream landscape. The robot-like creature in the centre holds up an eye which he has either bought from the behatted woman on the left or stolen from the little blind girl beside her.

Berne, Paul Klee Foundation

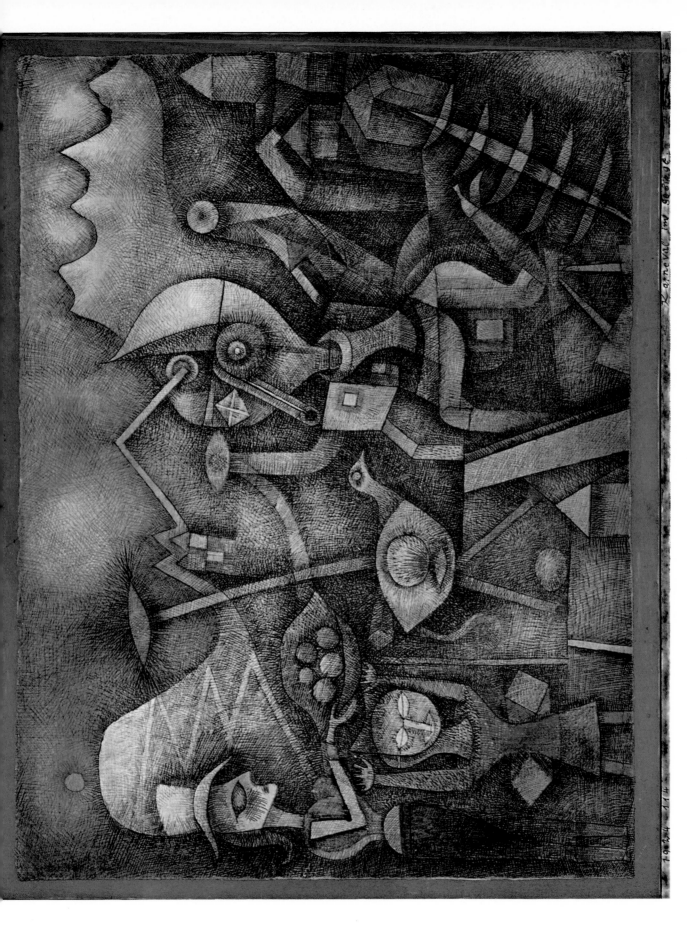

21. *Mocking-bird's Song*

1924. Watercolour and oil. 12 ×15½in (30·4 ×39·2cm)

The satirical purpose evident here is reminiscent of the so-called 'sour prints' which Klee had etched in Berne between 1903 and 1905; while the disembodied wire-like assemblages of bird and man, suspended in the void, link it to *The Twittering Machine* (*plate 15*). For Klee, birds often represent escape or transcendence. The mockery seems to be directed at the failure of the human figure to realize his higher aspirations. He topples down the steps made out of repetitions of his own climbing legs. The wave of his hair, curled into a question-mark, echoes the shape of the bird in the tree. Above a world in which everything is off-balance, the sun and moon hang side by side. The sleeve of the falling man appears to be transparent. This is because Klee has copied the idiom of a child who would perceive such an image in only two dimensions. Read this way, the sleeve drawn around the arm ensures that the arm is completely 'contained' within it.

Berne, Paul Klee Foundation

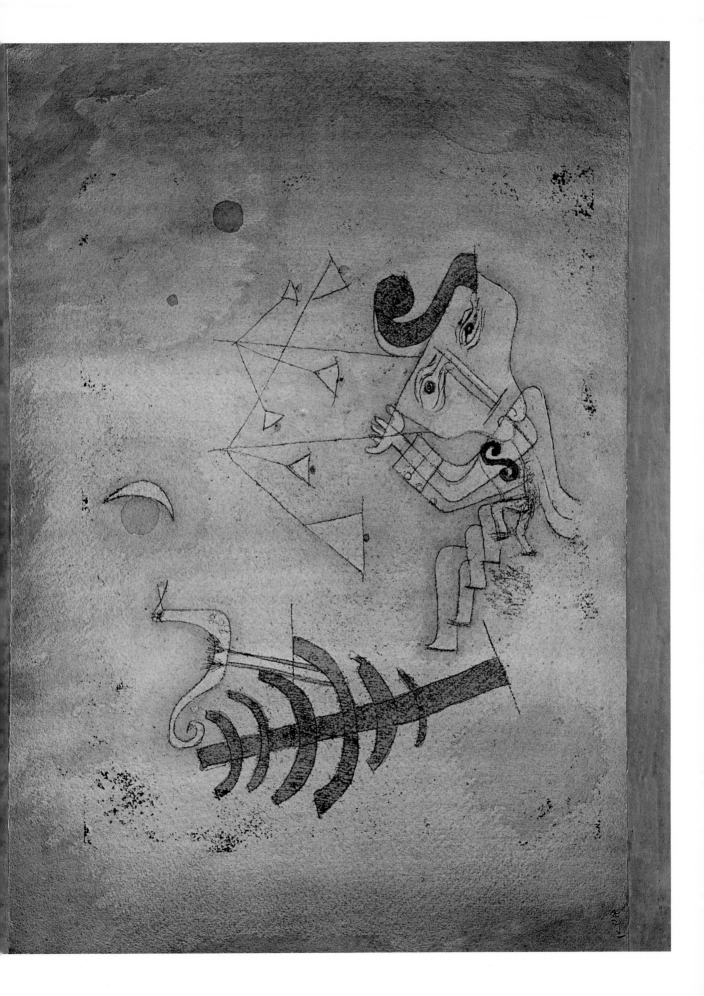

22. Fish Magic

1925. Oil and watercolour varnished. $30\frac{1}{4} \times 30\frac{5}{8}$ in (76·3 × 98·2cm)

Klee wrote: 'One can, once in a while, take a picture for a dream.' Everything in this dream admits of alternative possibilities. There is a sense of timelessness, yet Klee has carefully pointed the hands of the clock to the numbers that date the composition. The crescent moon cradles the sun in its lap. The presence of the fish suggests an aquarium, but the red curtain and the clown peering round from behind the scenes indicate that we are looking at a theatre set. As in paintings by Salvador Dali, the framework of white lines surrounding the clockface is at once a belfry and a fisherman's net. The two faces of the Janus-headed girl in the foreground suggest the pursed lips of the scholar and the heart-shaped lips of the vamp.

Philadelphia, Museum of Art

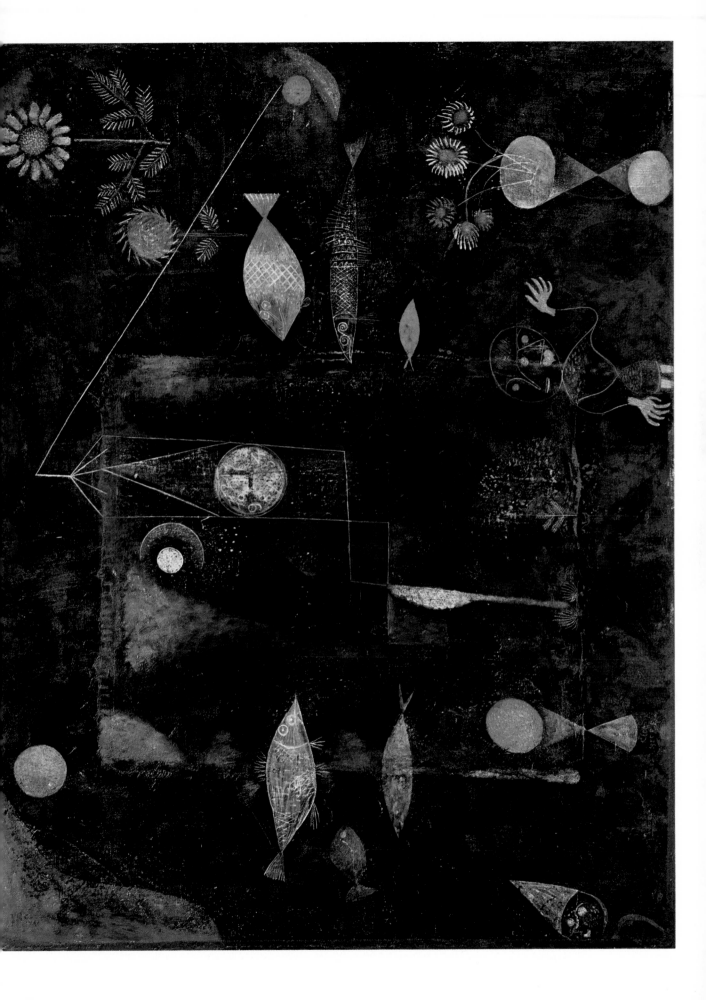

23. Golden Fish

1925. Oil on cardboard. $19\frac{1}{2} \times 27\frac{1}{4}$ in (49·5 ×69cm)

The bizarre parade of marine life which Klee had beheld as a young man on a visit to the aquarium at Naples prompted him to take up Nature's challenge to display comparable inventiveness in his art. The fish was a creature of special significance for Klee. Perhaps this is because it inhabits the mediate world of water into which men can look but where they cannot breathe, the fluid, transitory realm between our familiar elements of air and earth. The fish also had a religious significance and Klee was certainly alert to the sort of elision between alphabet and image by which the juxtaposing of the Greek letters 'kai' and 'rho' in Christ's name form a pictogram of a fish.

Hamburg, Kunsthalle

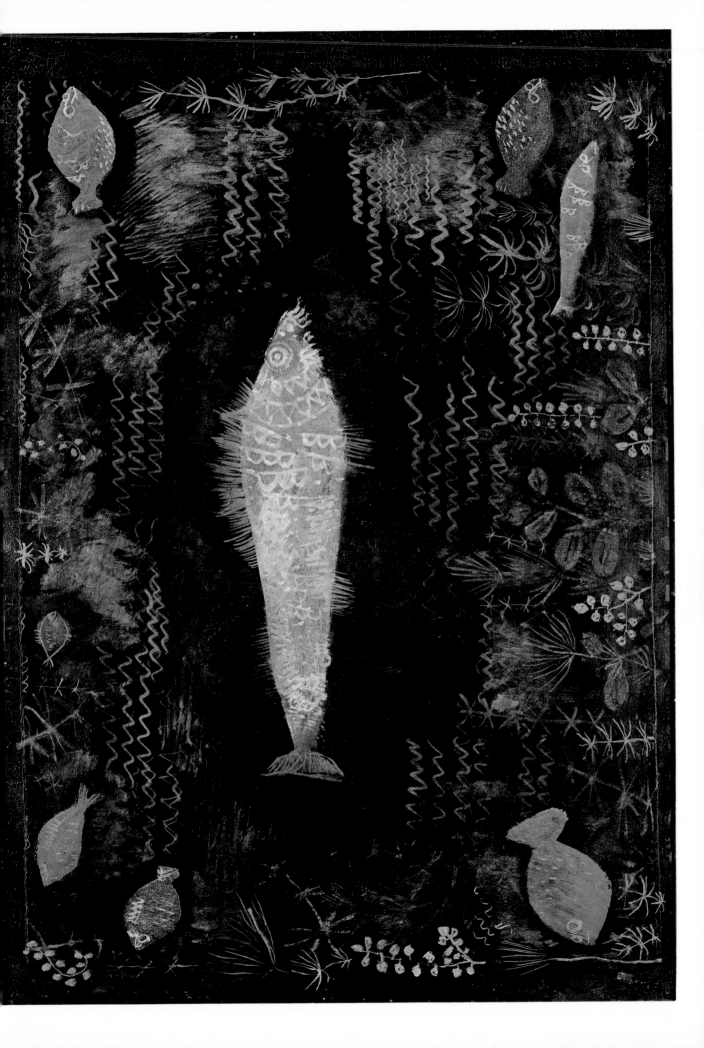

24. *Main Road and Side Roads*

1929. Oil. $32\frac{5}{8} \times 26\frac{3}{8}$ in (83 × 67cm)

Few paintings better demonstrate Klee's gift for relating observation and pictorial imagination than those which were inspired by his visit to Egypt in the winter of 1928–9, almost as momentous for him as his stay in Tunisia fourteen years before. In the landscape of the Nile valley with its margin of fertile land divided by irrigation ditches at right angles to the river and reaching out towards the desert ridges on either side, Klee found the model for a series of paintings composed of piled-up horizontal layers of subtly modulated colour bands — he called them 'strata' — which carry the picture upward and convey a sense of limitless spatial fluidity.

Munich, Frau Werner Wohwinckel Collection

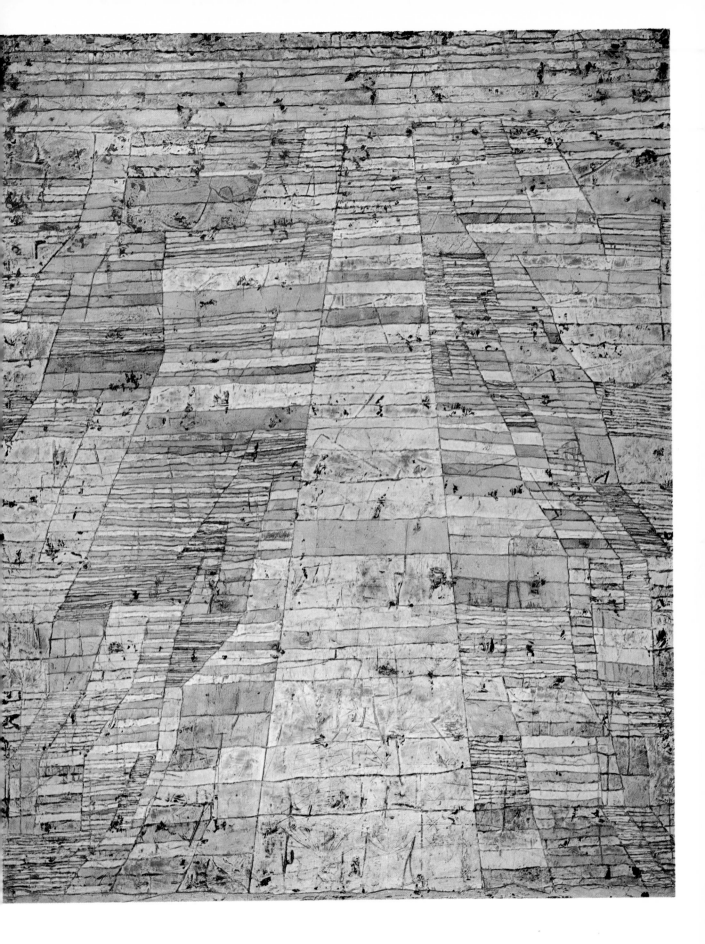

25. *Monument in a Fertile Country*

1929. Watercolour, paper on cardboard. $18\frac{1}{8} \times 12in$ (46 × 30·5cm)

Abstract and uncluttered as it is, this picture evokes both the blinding light of the desert and the resonance of five thousand years of the human past preserved in the landscape of contemporary Egypt. As in the previous picture, Klee is employing a personal formula to suggest the variety of physical and mental impressions made upon him by the land of the Pharaohs. He wrote in *The Thinking Eye*: 'It is interesting to observe how real the object remains in spite of all abstractions . . . There are times when something almost seems to be painted after nature, from a model so to speak.'

Berne, Paul Klee Foundation

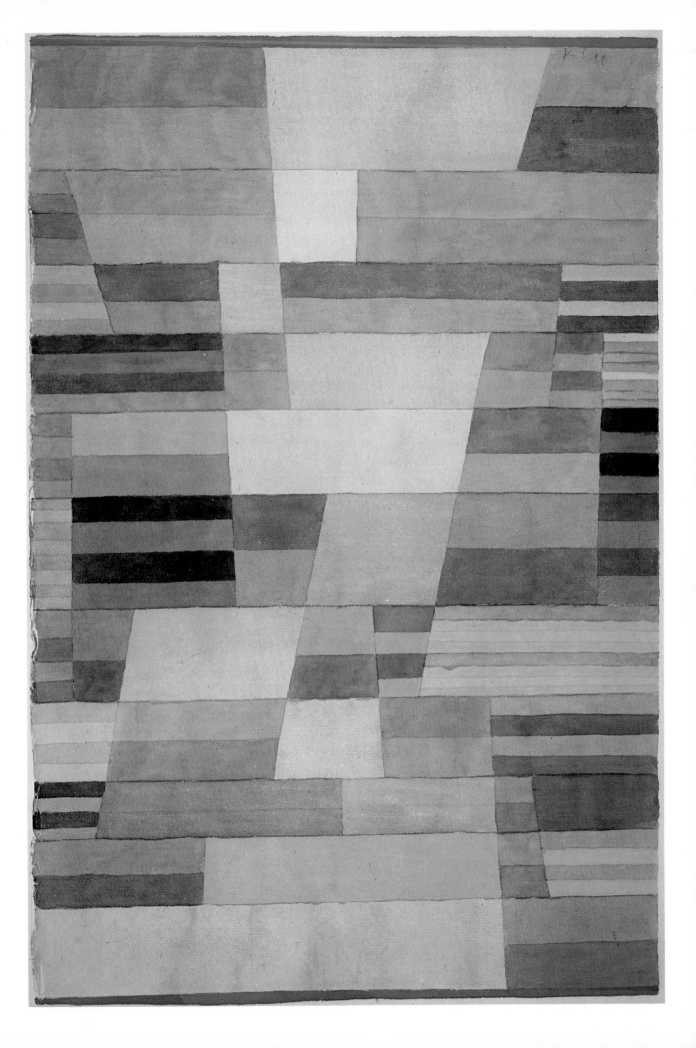

26. Ad Marginem

1930. Oil. 17⅜ × 13½in (44 × 34·5cm)

This centrifugal composition has the terrestrial elements literally relegated 'to the margin'. Here we find many of Klee's favourite motifs: plants and flowers, staring eyes, letters of the alphabet. But the oriental and recent Egyptian influence is very strong, not only in the figure of the bird wading upside down at the top of the picture, but also in the central image of the sun which is surrounded by an aura of tiny lines of energy. Klee here exploits the simple optical illusion which causes the sun to appear to change position as the viewer's eye roves around the picture.

Basel, Kunstmuseum

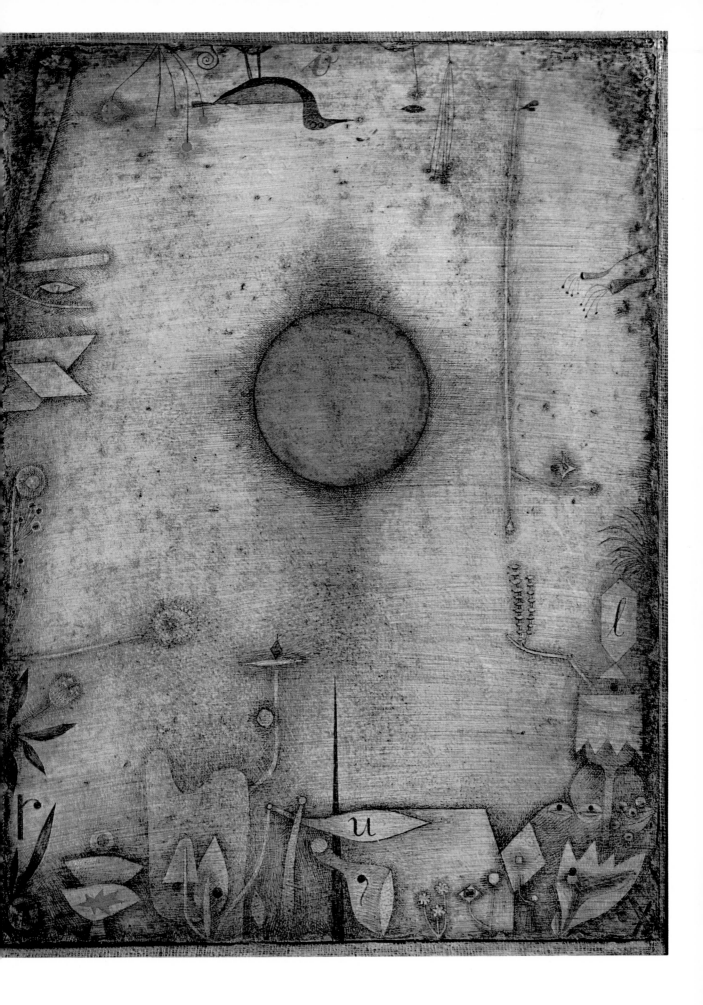

27. *Hovering — before the ascent*

1930. Oil. $31\frac{1}{8} \times 31\frac{1}{8}$in (84 ×84cm)

The braced surfaces of this painting and the scaffolding
of struts and coloured quadrangles recall some crazy
box-kite or, perhaps, the primitive aeroplanes which
Klee had been detailed to repair during the First World
War. All the elements here — the half-completed volumes,
the perforated and transparent planes, the angles within
the structure and the bright colours — are designed to
describe a state of weightlessness, in defiance of gravity.
Hovering is one of the most obviously 'constructivist' of
Klee's works; it could even be a parody of the orderly
progression of planes in abstracts by Moholy-Nagy. But
the arrow predicting the ascent and the indistinct cloud
of pink and green in which the mysterious constellation
floats, prove that Klee's Romantic spirit is as active here
as ever.

Berne, Paul Klee Foundation

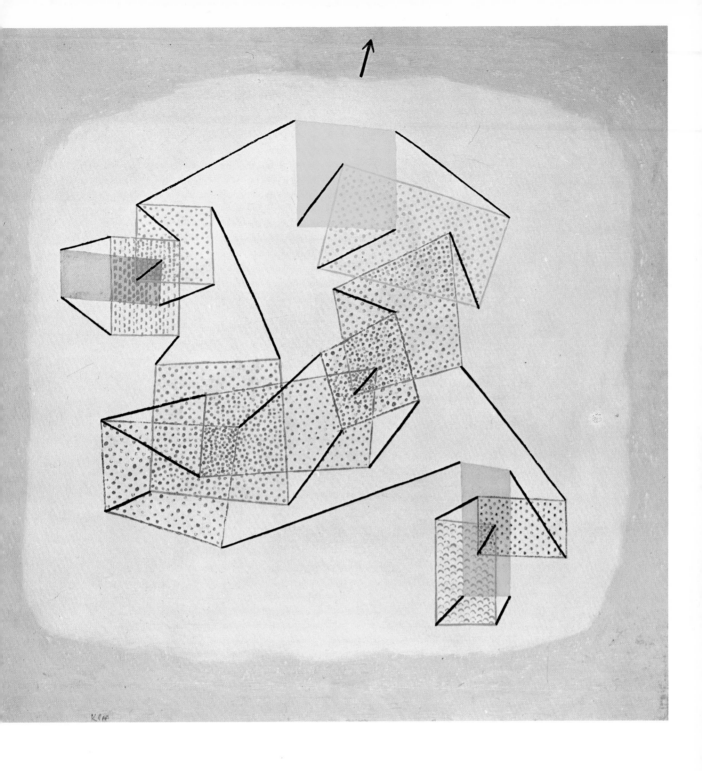

28. *Table of Colour*

1930. Paste on cardboard. $19\frac{1}{4} \times 11\frac{3}{4}$in (49 × 30·1cm)

Klee produced at least one 'magic square' painting each year between 1923 and 1937. It seems that he was particularly attached to these works and loath to part with them. Will Grohmann places them in the 'innermost circle' of his *oeuvre*, which includes those paintings which approach most closely to Klee's idea of absolute pictorial autonomy and from which all traces of narrative and representational elements have been banished. This colour grid has the same overall flatness as a chessboard, which some of Klee's colleagues at the Bauhaus regarded as the most perfect structural organization of a surface. Everything here depends on the action which occurs between the rectangles and on the harmonies achieved through the unbroken series of juxtaposed colour-tones.

Berne, Paul Klee Foundation

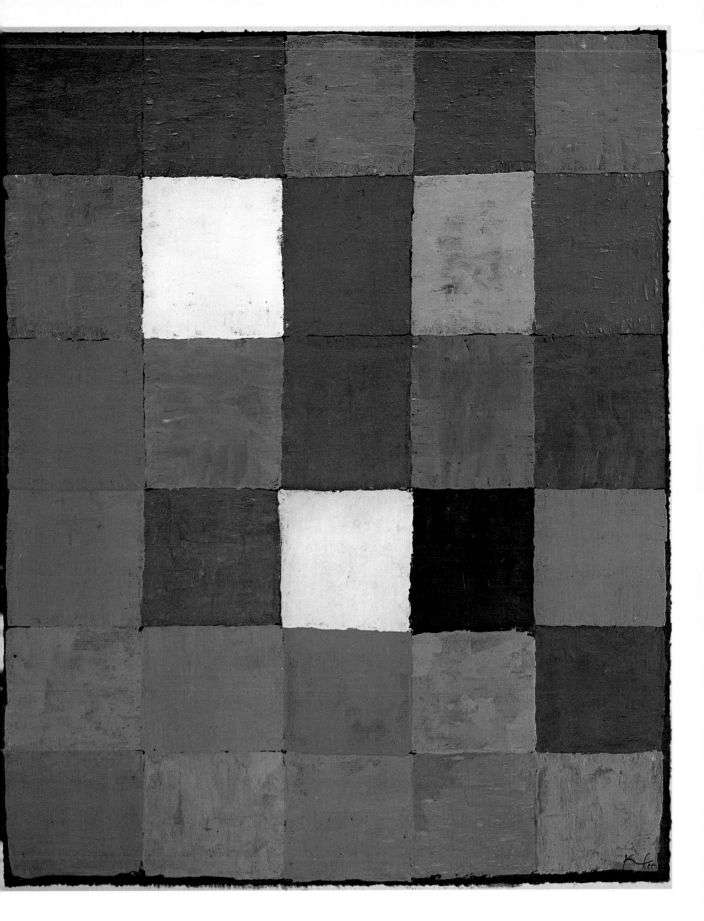

29. *Ad Parnassum*

1932. Oil. $39\frac{3}{8} \times 49\frac{5}{8}$in (100 × 126cm)

Klee gave the name 'Divisionist' to the series of paintings composed of constellations of coloured dots on which he worked during his years at Düsseldorf. *Ad Parnassum* was much the largest work he produced before 1937. In its shimmering and vibrant handling of pure light, this *magnum opus* amounts to a recapitulation of Klee's central preoccupations and explorations up to that date. According to Andrew Kagan, the title is a reference to the treatise by Johann Joseph Fux, *Gradus ad Parnassum*, a landmark in music theory and counterpoint which had been published in 1723. Klee had set himself the task of finding the pictorial equivalent of polyphonic composition, which he regarded as the key to the development of the visual arts in our day. In these terms, Klee's *Ad Parnassum* can be seen as his codification of pictorial polyphony, in which he plays off against each other the contrapuntal themes of gateway and mountain, blue and orange, the graphic and the colouristic.

Berne, Kunstmuseum

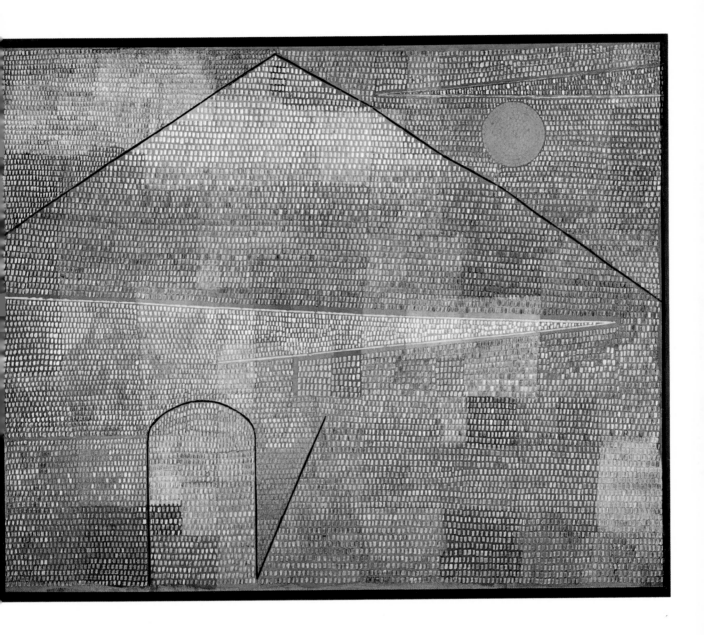

30. *Arab Song*

1932. Oil. 36 × 25in (91 × 64cm)

'Paul Klee, an Oriental?', René Crevel asked in 1929 in
the first of many tributes from the French Surrealists.
He answered his own question: 'Yes, beyond a doubt,
since some of his pictures seem woven in homage to the
freshest visions of the *Thousand and One Nights*.' This
would have been an apt comment on *Arab Song*, which
subtly plays on the ambiguity between a veiled face and
a curtained window looking out onto a desert landscape.
The picture contains the elegant motif of a heart with
a pinched tip, one of those symbols full of meaning yet
without a precise reference of which Klee was so fond.
Here the heart shape is attached to a stem and can be
read as a leaf.

Washington, Phillips Gallery

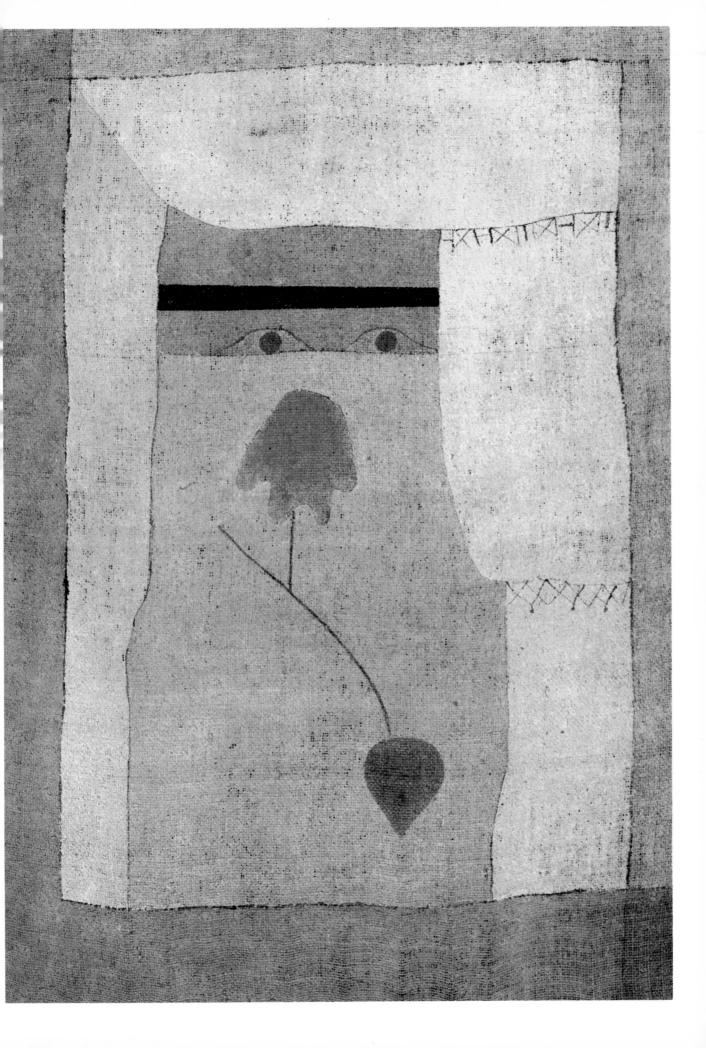

31. *Overland*

1937. Paste medium and pastel on cloth. $13 \times 22\frac{1}{2}$in
(32 × 57cm)

Klee's career suffered an understandable hiatus when he
was dismissed from his teaching post at the Düsseldorf
Academy and had to flee to Switzerland after the Nazi
takeover of power in 1933. This upheaval was followed
in 1935 by the onset of the disease which was to prove
fatal five years later. He discovered, however, a fresh
creative impetus in 1937 which marks the start of his
'late period'. *Overland*, like *Insula Dulcamara* and *Park
near Lu*, belongs to his so-called 'bar and line' series.
These are large-scale horizontal panels featuring bar-like
contours combined with striking colour-schemes which
exploit the richly luminous potential of the pastel
medium. The heavily brushed-in black lines and the
'fields' of colour suggest a landscape viewed from above.

Berne, Felix Klee Collection

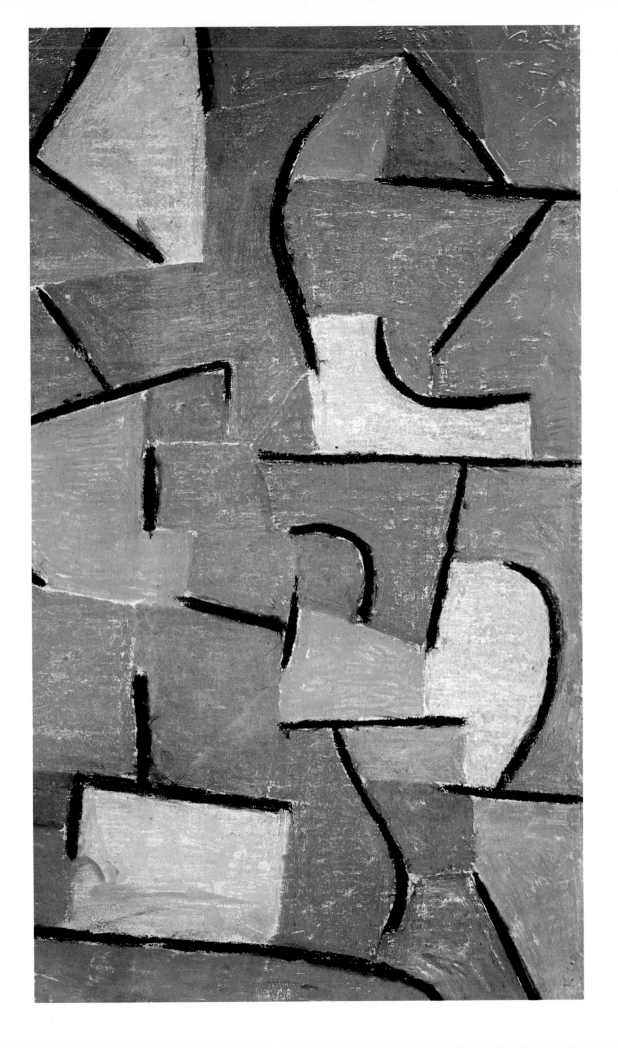

32. *Revolution of the Viaduct*

1937. Oil. $23\frac{1}{2} \times 19\frac{3}{4}$in (60 × 50cm)

Klee was one of the most private of twentieth-century
artists and produced few paintings making circumstantial,
political comment. But this painting, surely, is an image
of approaching war and of times out of joint. Klee
produced four versions of it in 1937, the same year as
Picasso's *Guernica*. The viaduct, a great piece of human
engineering, has taken itself to pieces. The arches have
grown legs. A jostling, undisciplined headless horde,
these bridge-men bear down upon the viewer and there
seems to be no escape. The simple units with their
sharply defined black contours and the intense colours,
ranging from violet to red and cadmium yellow, convey
a tangible threat.

Hamburg, Kunsthalle

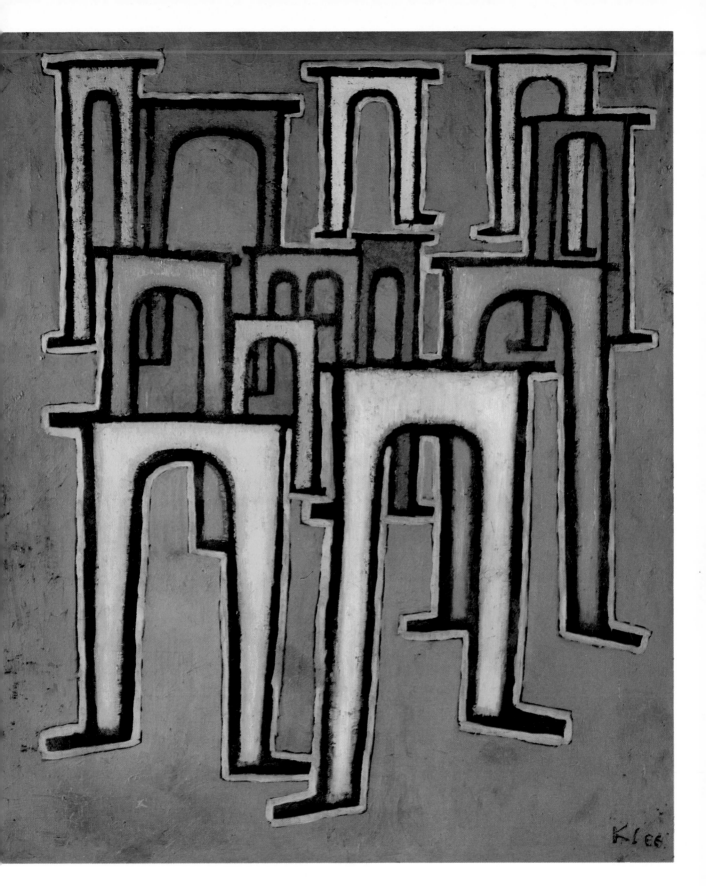

33. *Insula Dulcamara*

1938. Oil on burlap. 35 × 70in (89 × 176cm)

The bold, black graphic signs which became increasingly insistent in Klee's work after *Ad Parnassum* may have a number of connotations here. Rhythmically drawn and structuring the whole immense surface, they mark out the contours of the coastline of this Arcadian 'Island of Nightshade'; they can also be seen to indicate the pathways that thread across it, or they can stand for the privileged serpents who, in company with the mythical 'head-creature' in the centre, are its indigenous inhabitants. The soft, vernal colours gently merge, the sun both rises and sets, and a ship passes by on the horizon. It is a bitter-sweet meditation on the theme of travel and escape by an artist more and more confined to an armchair.

Berne, Paul Klee Foundation

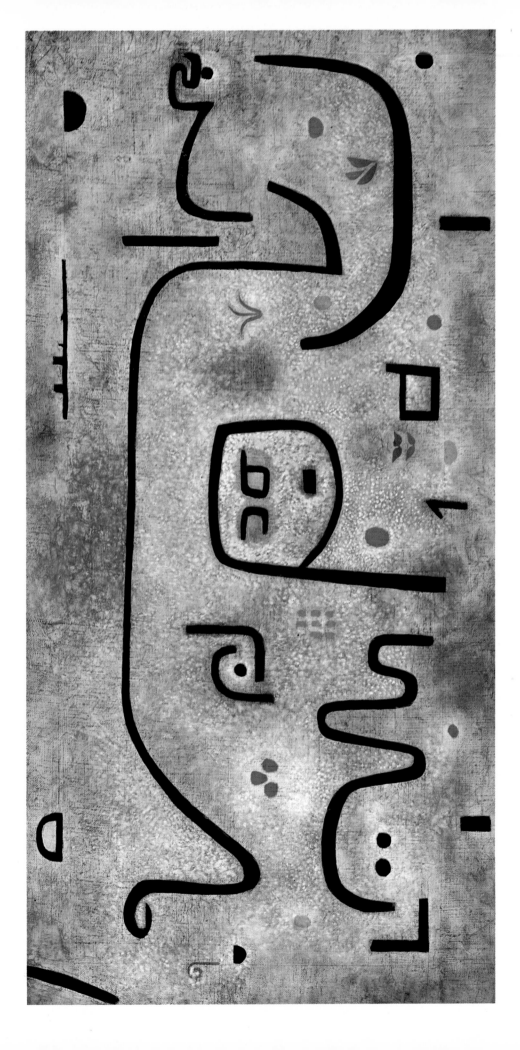

34. *Park near Lu(cerne)*

1938. Oil. $39\frac{3}{8} \times 27\frac{5}{8}$ in ($100 \times 70cm$)

Paths, tree forms, waving figures, blossom time and winter bareness — all the animation of a public park in its changing seasons is suggested here in one of Klee's gayest pictures from the late 'thirties. Its vibrancy comes largely from the arrangement of the colour, starting from the black outlines with their white margins, to the bright zones of yellow, red, orange and raspberry, and the subtly variegated blues of the 'background'. If the graceful little fir-tree is a provisional centre of focus, the eye is free to roam over the entire picture-field, discovering ever new formal relationships.

Berne, Paul Klee Foundation

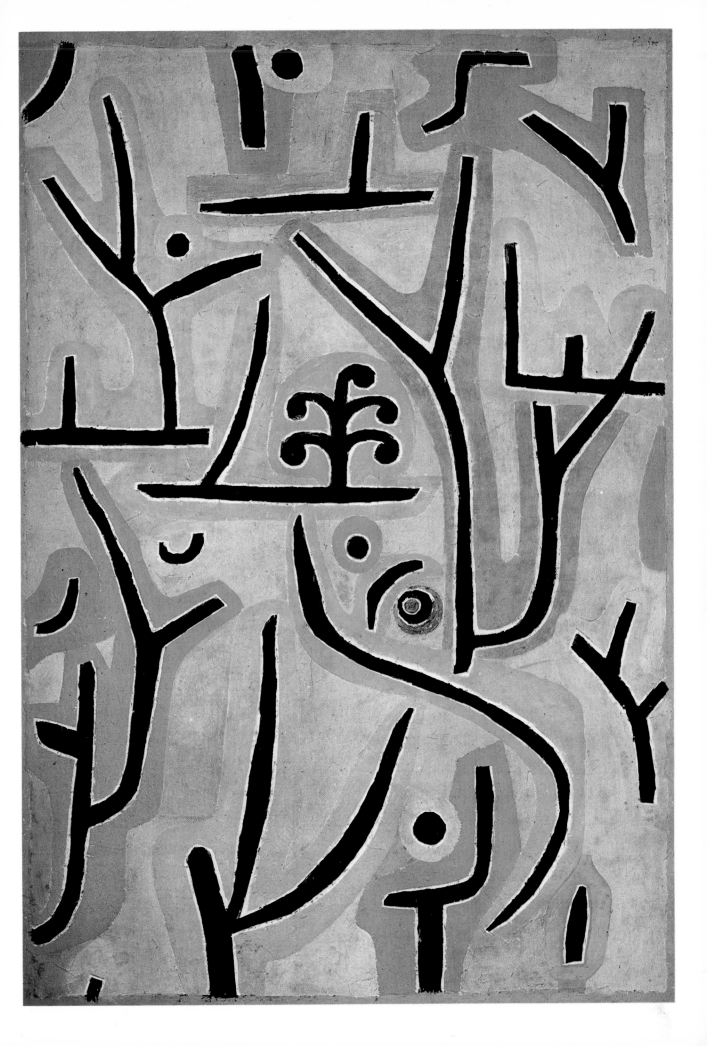

35. *Flowers in Stone*

1939. Oil on cardboard. $19\frac{5}{8} \times 15\frac{5}{8}$ in (50·1 × 39·6cm)

Like *Senecio*, here is another circular shape in frontal
view, almost filling the picture. But in place of the
delicate, tentative outline of 1922, we have a contour
which is thick and assertive, like the leading in a stained-
glass window. The flower symbols resemble embedded
fossils and the patina is stony, as if belonging to some
massive ancient totem or dolmen; but other elements in
the picture remind us of its two-dimensionality, and we
could read the stone circle as a tilted Cubist table-top.

Lucerne, Galerie Rosengart

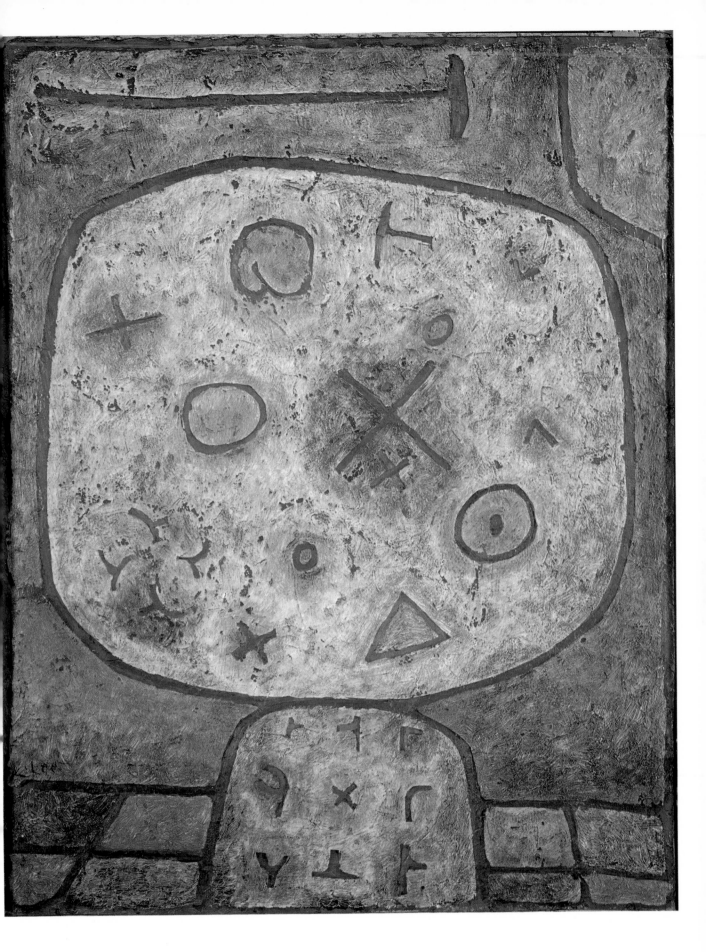

36. *La belle Jardinière*

1939. Oil and tempera. $37\frac{3}{4} \times 27\frac{1}{2}$in ($96 \times 71$cm)

In his last years, Klee turned back towards his expressionist roots, to his 'original realm of psychic inspiration'. *La belle Jardinière* is one of a number of portraits of spectral figures and idols which must have risen directly from the artist's unconscious. The shapes and colours of the background suggest the vegetable beds from which this disquieting apparition may have gathered her tray of produce. Klee also called her a 'Biedermeier spirit', which suggests a certain cosiness. One may feel that she has less in common with the secular goddesses of fertility painted by Raphael than with that other gardener, Death the reaper.

Berne, Paul Klee Foundation

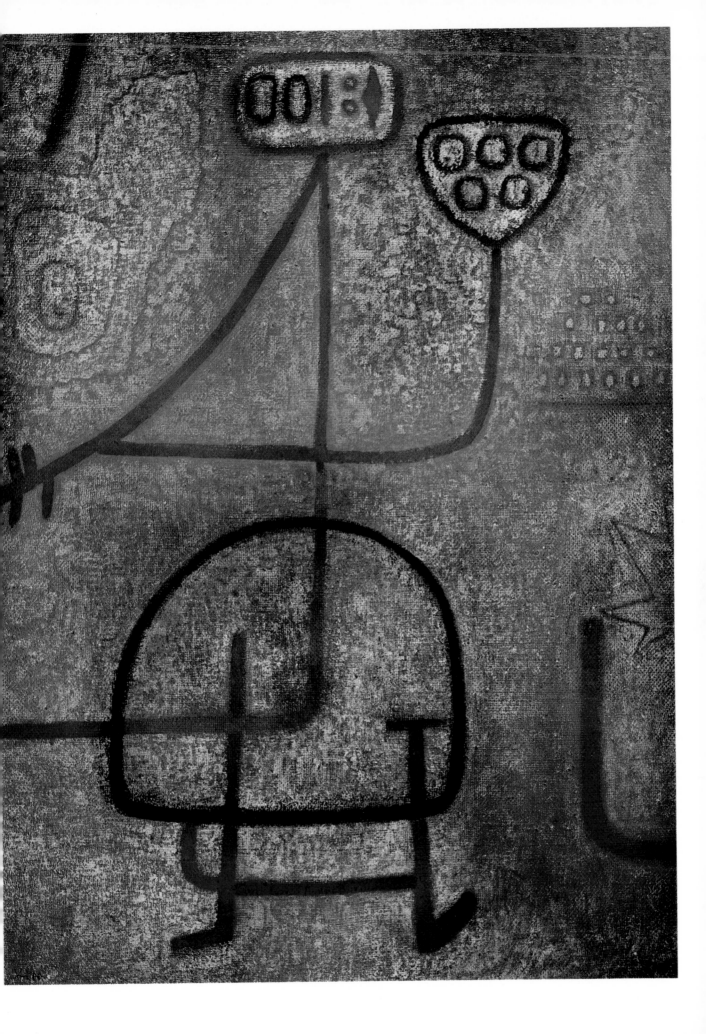

37. Mask

1940. Pastel and crayon. $11\frac{3}{4} \times 13\frac{1}{8}$ in ($30 \times 33 \cdot 5cm$)

In the works of Klee's amazingly prolific last years, the figures of angels and demons abound in much the same way as had fishes in the early 'twenties. As he drew near death, Klee sought to express the transition from the material world to that of the spirit. This fiercely glowing visage with its violent distortions may relate to Picasso's paintings of the mid-thirties, but equally it resembles a Peruvian death's-head with its tight, interlocking design, vacantly staring eyes and teeth capable of functioning both frontally and in profile. Klee's embodiments of the demonic threat and of approaching death are almost as varied and inventive as his earlier images of vigorous life.

Berne, Paul Klee Foundation

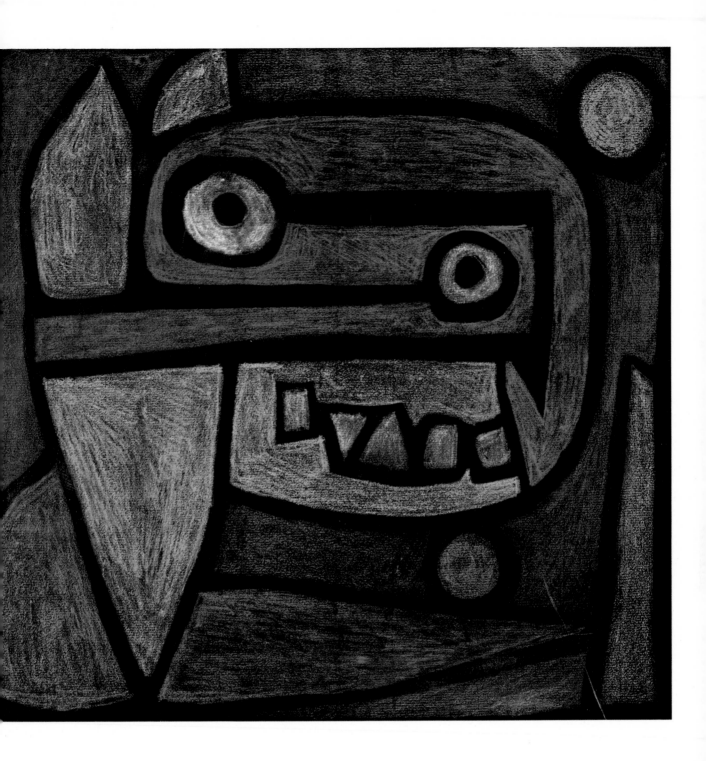

38. *Death and Fire*

1940. Oil and size. $18\frac{1}{2} \times 17\frac{3}{8}$in (47 \times44cm)

Here Death is confronted face to face. His ashy skeletal features are formed by the three letters of his German name: Tod. The greeny blue of his shoulders and arm suggests the river Styx while his hand is the horizon beneath the setting sun or the Sphere of Fate, towards which, bearing a pilgrim's staff, walks the soul of the dead. In this concise and formidable ideogram, each element of the picture merges with its neighbour and the image fluctuates before the eyes, for all are joined in Death.

Berne, Paul Klee Foundation

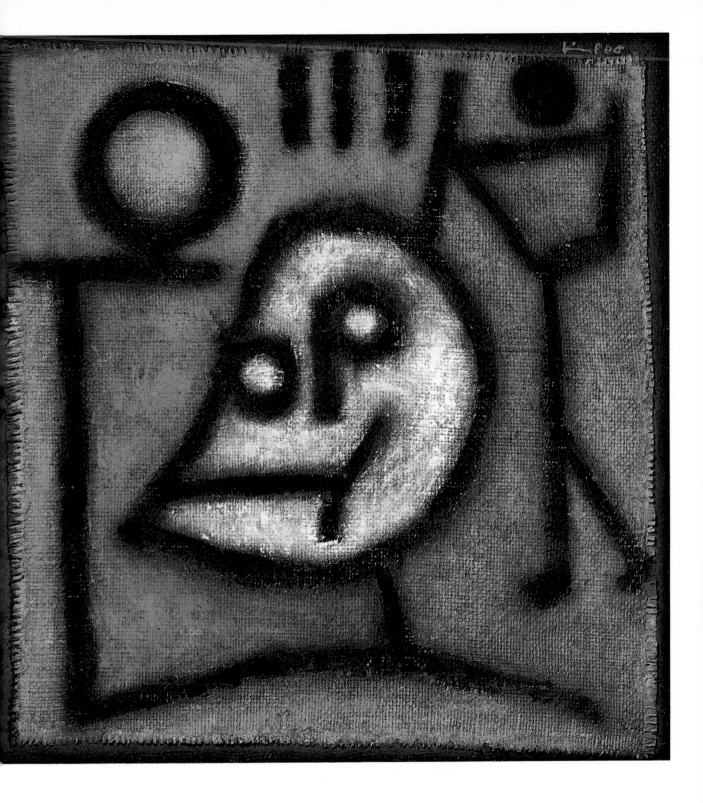

39. *Cupboard*

1940. $16\frac{1}{4} \times 11\frac{5}{8}$in (41·5 × 29·5cm)

Although the little feet proclaim this to be a piece of furniture, this grandiose image belongs with Klee's lengthy series of gateways and portals. One might guess that the blank but glowing door of this cupboard conceals what the following picture so graphically reveals (for Klee identified the doorway with intimations of mortality). Here, as with a number of his paintings of 1940, the spontaneity of the pictorial gesture, the extreme economy of means, and the exploitation of the picture margins look forward to post-war Abstract Expressionism. The colour is not so much brushed on as rubbed into the surface.

Berne, Collection Felix Klee

40. *Still Life*

1940. Oil. 39$\frac{5}{8}$ × 31$\frac{1}{2}$in (100 × 80·7cm)

In this, his last painting, which was left unsigned and
untitled, Klee has set aside the ashy whites and fiery reds
of his infernal palette in favour of the more cheerful
colours of earlier work. The bulging protuberances of the
greyish-purple pieces of sculpture and of the teapot are
positively jaunty. Each object here seems endowed with
a life of its own. There is a strong sense of discontinuity;
and the imminence of death is alluded to enigmatically
in the picture-within-a-picture of a wrestling angel, and
in the disquieting treatment of the flowers which might
have been scattered on a grave.

Berne, Collection Felix Klee

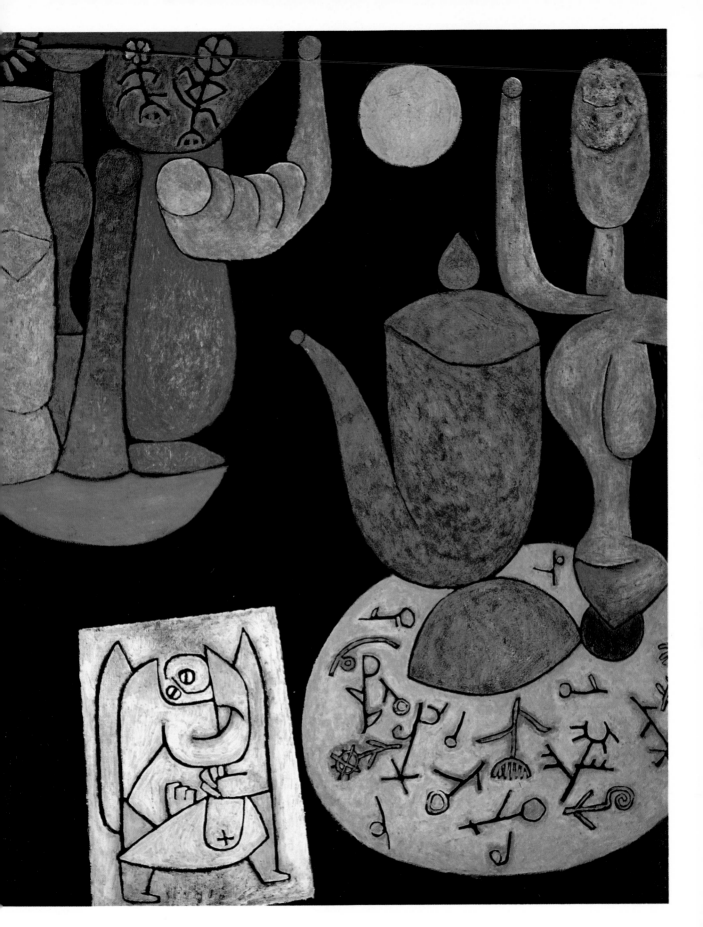

Acknowledgements, and list of illustrations and sources

THE AUTHOR AND BLACKER CALMANN COOPER LTD would like to thank the museums and owners who allowed works in their collections to be reproduced in this book. Unless otherwise stated they provided the transparencies used. All the illustrations are copyright © 1979 by Cosmopress, Geneva, and SPADEM, Paris. The author and Blacker Calmann Cooper Ltd would also like to thank the photographers and photographic agencies who provided transparencies.

1. *Garden Scene with Watering-Can* — Berne, Collection Felix Klee
2. *Girl with Jugs* — Berne, Collection Felix Klee
3. *Red and White Domes* — Düsseldorf, Kunstsammlung Nordrhein-Westfalen
4. *Abstraction: coloured circles with coloured bands* — Berne, Paul Klee Foundation
5. *The Niesen* — Berne, Hermann and Margit Rupf Foundation
6. *City of Towers* — Philadelphia, Museum of Art
7. *Demon over the Boats* — New York, Museum of Modern Art
8. *Villa R* — Basel, Kunstmuseum. Photo Hans Hinz
9. *Self-Portrait (lost in thought)* — Berne, Collection Felix Klee
10. *Landscape near E (in Bavaria)* — Berne, Paul Klee Foundation
11. *Greeting* — Hartford, Conn., Wadsworth Atheneum (Ella Gallup Sumner and Mary Catlin Sumner Collection)
12. *Growth of Nocturnal Plants* — Munich, Stangl Gallery
13. *Vocal Fabric of the Singer Rose Silber* — New York, Museum of Modern Art
14. *God of the Northern Forest* — Berne, Paul Klee Foundation
15. *The Twittering Machine* — New York, Museum of Modern Art
16. *Young Girl's Adventure* — London, Tate Gallery
17. *Senecio* — Basel, Kunstmuseum. Photo Hans Hinz
18. *Magic Theatre* — Berne, Paul Klee Foundation
19. *Actor* — Berne, Collection Felix Klee
20. *Mountain Carnival* — Berne, Paul Klee Foundation
21. *Mocking-bird's Song* — Berne, Paul Klee Foundation
22. *Fish Magic* — Philadelphia, Museum of Art (Louise and Walter Arensberg Collection)
23. *Golden Fish* — Hamburg, Kunsthalle
24. *Main Road and Side Roads* — Munich, Frau Werner Wohwinckel Collection
25. *Monument in a Fertile Country* — Berne, Paul Klee Foundation
26. *Ad Marginem* — Basel, Kunstmuseum. Photo Hans Hinz
27. *Hovering — before the ascent* — Berne, Paul Klee Foundation
28. *Table of Colour* — Berne, Paul Klee Foundation
29. *Ad Parnassum* — Berne, Kunstmuseum
30. *Arab Song* — Washington, Phillips Gallery
31. *Overland* — Berne, Collection Felix Klee
32. *Revolution of the Viaduct* — Hamburg, Kunsthalle
33. *Insula Dulcamara* — Berne, Paul Klee Foundation
34. *Park near Lu(cerne)* — Berne, Paul Klee Foundation
35. *Flowers in Stone* — Lucerne, Galerie Rosengart. Photo Fred Wirz
36. *La belle Jardinière* — Berne, Paul Klee Foundation
37. *Mask* — Berne, Paul Klee Foundation
38. *Death and Fire* — Berne, Paul Klee Foundation
39. *Cupboard* — Berne, Collection Felix Klee
40. *Still Life* — Berne, Collection Felix Klee